Gallery Plan

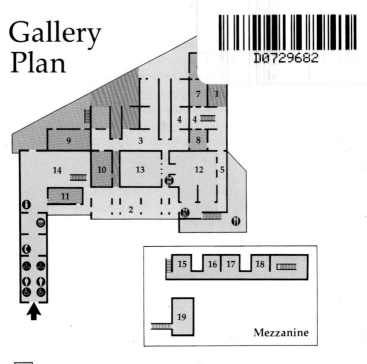

Mezzanine

▦ **Ancient Civilizations**

▨ **Oriental Art**
1 Carpets and Near Eastern Ceramics

Medieval and Post Medieval European Art
2 Stained Glass and Furniture
3 Tapestries
4 Needlework and Lace
5 Sculpture

Period Galleries
6 Elizabethan Room
7 17th and 18th Century Room
8 Gothic Domestic Room

The Hutton Castle Rooms
9 Drawing Room
10 Hall
11 Dining Room

12 Temporary Exhibition Area
13 Lecture Theatre
14 Courtyard

🔵 Shop
ℹ Enquiry Desk
© Telephone
♦ Cloakrooms
○ Ladies Toilet
○ Gents Toilet
🔵 Disabled Toilets
⊕ Restaurant
🔵 Disabled Lift
🔵 Lift
▥ Stairs

Mezzanine

Paintings and Drawings
15 Old Masters
16 19th Century French
17 Pastels: Degas and Manet
18 Special Displays from The Collection

THE GUIDE TO

THE
BURRELL
COLLECTION

1 Sir William Burrell (1861-1958) *This photograph was taken by the well-known Glasgow firm of photographers, T & R Annan, when Burrell was aged about sixty. It is one of the few photographs of Sir William Burrell, an intensely private man, who resolutely refused to sit for a portrait to be placed in the gallery. He used to say:*
 'The collection, not the collector, is the important thing.'

THE GUIDE TO

THE
BURRELL
COLLECTION

Chambers

First published 1985 by Richard Drew Publishing
Second edition 1990

This edition published 1991 by W & R Chambers Ltd,
43–45 Annandale Street, Edinburgh EH7 4AZ

British Library Cataloguing in Publication Data

A catalogue record for this book is
available from the British Library

ISBN 0-550-22564-1

Printed in Great Britain by
Wood Westworth Ltd
St Helens, Merseyside

CONTENTS

FOREWORD

This opportunity to publish the revised edition of the highly successful pocket guide to the Burrell Collection arises at precisely the right moment at the beginning of Glasgow's year as European City of Culture. We have opened our important new temporary exhibition facility and at the same time have taken the opportunity to redisplay some important areas of the Collection in ways which we hope visitors will find stimulating and enjoyable.

Originally written by Dr Richard Marks, the book has been revised and brought up to date by the current curatorial staff at the Burrell Collection. We hope that it will contribute to visitors' continuing enjoyment of the Collection and we hope too that the pleasure and interest generated here will encourage visits to other Glasgow city museums; to the Rembrandts at the Art Gallery and Museum, for example, or to the El Grecos and Blakes at Pollok House, not five minutes further into Pollok Park from the Burrell. This guide is one of Glasgow Museums and Art Galleries' contributions to 1990 and we trust it will be a notable success.

Art Gallery and Museum
Kelvingrove
GLASGOW G3 8AG

Julian Spalding
DIRECTOR
March 1990

INTRODUCTION

Since the opening ceremony, performed by Her Majesty the Queen on 21st October 1983, the Burrell Collection has welcomed almost 5 million visitors. Although many have come from the local area, a significant proportion has travelled considerable distances, attracted by the widespread, and favourable, publicity which the Collection and its stunning new home have achieved. Indeed, the opening of the Burrell has been described as 'the major turning point in Glasgow's future as a visitor base', a milestone in the renaissance of its home city.

The Burrell Collection is one of Glasgow's group of nine civic museums and art galleries, funded by Glasgow District Council. The Burrell also receives generous financial support from Strathclyde Regional Council. All very different in character and appeal, the nine museums and art galleries have enjoyed the faithful support of Glaswegians for decades.

Not only is the new edition of this short Guide being printed in 1990, a year of especial importance to Glasgow, but it is also marking the next stage of the Burrell Collection's development. Glasgow is celebrating its 'reign' as European Capital of Culture, a year-long festival of popular culture — music, theatre, visual arts, sport. Events encompass those involving international guests and the local community. There is something for everyone! One of the aims of 'Culture Year' is to leave the city a legacy of improved or new facilities. Undoubtedly the most prestigious are the re-opening of the marvellously refurbished McLellan Galleries, one of our sister museums, and the opening of the new International Concert Hall in October. Most exciting for the Burrell, however, is the dedication of a space within the building to temporary exhibitions. A varied programme is planned, and all the exhibitions which the Burrell will house are intended to enhance our understanding of Sir William's Collection.

In creating the exhibition space within the building, we have taken the opportunity to re-display large sections of the Collection. Ancient Civilizations and Chinese Bronzes and Ceramics have been extensively re-arranged and augmented, the Carpets and Furniture have been given new homes within the building, and the Textile display has been completely renewed. A Lace gallery has been created, entirely due to public demand. The most dramatic change has been in the re-hanging of the Painting galleries. Now located in

the four Mezzanine rooms, the paintings have been given an immeasurably more sympathetic display environment, encouraging the visitor to examine and to enjoy.

The Burrell Collection was formed by one man, Sir William Burrell. A uniform display system has been used throughout the main gallery – wall colours, display fabric, stands, type of labels – to emphasise that this is not an historical display but very much a personal collection, reflecting the tastes, interests and character of this one man. Displays are changed frequently, especially where sensitive items might suffer long-term damage if they remained even in controlled lighting for lengthy periods. It has sometimes been difficult for visitors to be aware of the changes, due to the uniform display system. Such is the scale, however, of the recent re-display that it will be a stimulus to regular visitors, and heighten the enjoyment of newcomers.

Grateful thanks are due to former and to current colleagues in the compiling of this new edition of the Guide: Dr. Richard Marks, former Keeper of the Collection and writer of the first edition of the Guide, on which this second edition is based; curatorial colleagues Jimmy Thomson, Vivien Hamilton and Nick Pearce for their imaginative and constructive assistance; the Burrell's conservation staff, Janet Notman, Bill McHugh, Linda and Graeme Cannon, Jane Porter, Ann French and Sophie Younger, and Frank Laydon for their unceasing care and protection of the physical well-being of the Collection, thus allowing the objects to be shown in their full glory. Linda Simi, Winnie Tyrrell, Louise Devlin and Sandra Gibbs are to be congratulated on their patience in preparing the text. All photographs in the Guide, except where specific credit is listed, including those taken for the new edition, have been prepared by the Photographic Section of Glasgow Museums & Art Galleries.

Any museum owes much of its character and appeal to the endeavours of its staff. All those listed above have shown exceptional commitment in developing and creating the new displays, and are ably supported by all the museum assistants and other colleagues in presenting the Burrell Collection, Sir William and Lady Burrell's extraordinary gift to their native city, to all our visitors.

<div align="right">

Rosemary A. Watt
Keeper
The Burrell Collection

</div>

THE BURRELL COLLECTION CHRONOLOGY

1861	9 July: William Burrell born in Glasgow
1875	William Burrell joins the family shipping firm of Burrell & Son
1885	On death of their father he and his brother George take over management of Burrell & Son
1899	William Burrell elected to the Council of Glasgow Corporation and becomes convenor of a sub-committee on health
1901	Glasgow International Exhibition: William Burrell the largest single lender. He marries Constance Mitchell
1902	The Burrells move into 8 Great Western Terrace, Glasgow, which had been re-modelled for them by their close friend Robert Lorimer. Birth of their daughter Marion
1911	William Burrell starts recording his acquisitions in Purchase Books
1913-16	Sale of almost all of the Burrell & Son fleet
1916	Burrell buys Hutton Castle. Work commences on alterations under the direction of Robert Lorimer
1923	Burrell appointed Trustee of the National Galleries of Scotland
1927	Burrell moves into Hutton Castle. Knighted for his services to art in Scotland and public works. Appointed a Trustee of the National Gallery of British Art (now the Tate Gallery)
1944	Sir William and Lady Burrell donate the Collection to the City of Glasgow. He continues acquiring works of art
1946 ⎫	Sir William Burrell gives Glasgow £450,000 to meet the costs of the gallery to house the Collection
1948 ⎭	Search for a suitable site in progress
1957	22 June: last entries in the Purchase Books
1958	29 March: death of Sir William Burrell
1961	15 August: death of Lady Burrell
1967	Pollok House and Estate presented to Glasgow by Mrs Maxwell Macdonald and the Trustees of the Burrell Collection agree to housing it in Pollok Park

1972	The architectural competition for the design of the gallery won by Barry Gasson, John Meunier and Brit Andreson
1975	*Treasures from the Burrell Collection* exhibition at the Hayward Gallery, London
1976	The Secretary of State for Scotland announces a substantial grant towards the cost of the gallery
1978	4 May: Miss Burrell inaugurates work on the site
1983	21 October: The Burrell Collection gallery declared open by Her Majesty the Queen
	Barry Gasson awarded the Gold Medal for Architecture by the Royal Scottish Academy
1984	28 April: 500,000th visitor to the Collection
1984	12 September: 1,000,000th visitor to the Collection
	The Burrell Collection wins the following awards:
	(1) British Tourist Authority *Come to Britain* trophy for 1983
	(2) Stone Federation Award for Natural Stone 1983
	(3) Award for efficient use of energy from the Chartered Institution of Building Services
	Barry Gasson awarded the OBE
	Burrell Collection becomes the leading tourist attraction in Scotland
1985	Further awards won:
	(1) 1985 Museum of the Year Award
	(2) Scottish Museum of the Year Award
	(3) Sotheby's Award for the best Fine Art Museum
	(4) Scottish Museum of the Year Award for the best museum publication
	(5) Civic Trust Award
1986	(6) Glasgow Institute of Architects, Annual Design Award
	(7) Royal Institute of British Architects, Award for Scotland

USEFUL INFORMATION

Admission
Admission is free and the Burrell Collection is open throughout the year every day except Christmas Day and New Year's Day.
For opening times please contact The Burrell Collection.

How to Get There
The Burrell Collection gallery is set in the delightful surroundings of Pollok Park, about 10 minutes walk from Pollok House.

There is ample car parking space and there are buses from the city centre to the Pollokshaws Road entrance of the park about 20 minutes walk from the gallery.
By Bus:
For up to date details of bus services contact St Enoch Travel Centre, St Enoch Square, Glasgow G1, 041-226 4826.
By Rail:
Travel from Glasgow Central to Pollokshaws West station or Shawlands station.

Education Services
The Museum Education Service is administered by Strathclyde Region Education Authority and offers the following:

Teaching service for schools

In-service/in-training courses for teachers

Further Education programmes

For information contact:
The Museum Education Officer: Tel: 041-334 1131
041-649 9929

Guided Tours
There are daily conducted tours of the Collection. The times of the tours are announced on the Notice Board in the Courtyard. The service is organized by Glasgow Art Gallery and Museums Association; it is free and no advance booking is necessary.

Facilities for the Handicapped
There are reserved parking spaces close to the entrance and wheelchairs are available on request for use in the gallery. All areas of the gallery open to the public can be reached by lift and the lavatories are equipped for the disabled.

Cassette audio-guides for the visually handicapped are available from the Enquiry Desk.

Catering
The gallery has a self-service restaurant and a licensed bar.

Study Facilities
Items not on display and the records of the Collection are normally accessible to advanced students and specialists. Advance notice must be given.

Overnight accommodation is available for visiting scholars; preference will be given to those coming from overseas. This must be booked well in advance.

Photographic Services
In addition to the postcards, reproductions and slides on sale in the Shop, photographs and slides of items in the Collection can be ordered. Price lists and order forms are available.

Reminders
1. NO SMOKING IS PERMITTED
2. DO NOT TOUCH THE EXHIBITS

Details and further information from:
The Burrell Collection, Pollok Country Park, 2060 Pollokshaws Road, Glasgow G43 1AT. Tel: 041-649 7151

Glasgow Museums and Art Galleries, Art Gallery and Museum, Kelvingrove, Glasgow G3 8AG. Tel: 041-357 3929.

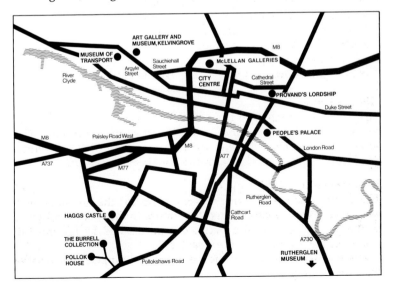

THE GUIDE

Although this guide is primarily concerned with the Collection proper rather than with its architectural setting, the latter is worthy of study in its own right. It is a modern design, but one which neither detracts from its position in the landscape nor overwhelms the objects displayed within. Indeed its position in the corner of the field and against woodland enables it to make full use of the natural possibilities presented by the site. From the west, the gallery gradually unfolds against the line of trees. The glass walls on the north and south sides reflect the surroundings and permit a continuous interplay between art and nature. The entrance arm and the east wall, with their cladding of red sandstone from Locharbriggs in Dumfriesshire, harmonize well with the exteriors of so many of the handsome Victorian and Edwardian tenement houses in Glasgow. The only item from the Collection displayed outside the building is the 17th-century sundial from Meggatland House in Midlothian.

The gallery is entered through the great oak double doors and sandstone arch in the façade. The arch comes from Hornby Castle in Yorkshire and dates from the 14th century. The creatures carved on the stonework belong to a long tradition of animal carving in Yorkshire sculpture. Only the carved stones are original; the remainder are from Cat's Castle Quarry in Gloucestershire and were cut when the arch was built into the gallery.

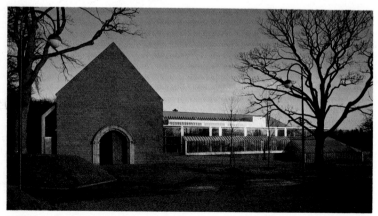

2 *The entrance arm and south side in winter.*

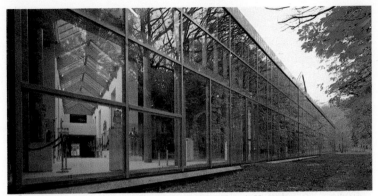

3 *The glazed north wall in autumn. Photograph by Alastair Hunter*

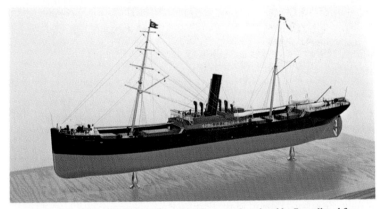

4 Model of the SS Strathclyde *One of the first vessels ordered by Burrell and Son when the firm was under the management of William Burrell and his brother George. The ship was built in 1889 by Alexander Stephen and Sons of Linthouse. Made of steel, she was powered by triple expansion engines and had a gross tonnage of 3265.*

Inside, the long and narrow Entrance Arm extends from the Lavatories and Cloakrooms to the Shop and Enquiry Desk. On the wall near the Shop is the plaque commemorating the opening of the gallery by Her Majesty the Queen on 21 October 1983 and nearby are several awards made to the Burrell Collection. On the opposite side is a Pay-phone and Letterbox and a wall-panel giving a brief account of Sir William Burrell and the Collection. A model of one of his ships, the *SS Strathclyde,* is a reminder of the source of the wealth which enabled Burrell to form such a large and comprehensive collection.

4

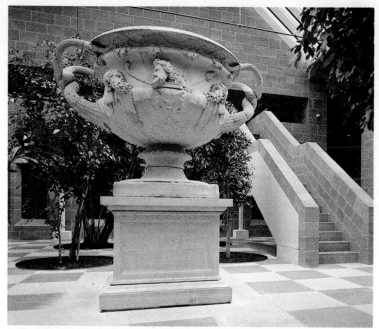

5 The Warwick Vase *Roman, with 18th-century reconstruction work on 2nd-century A.D. original Marble, height 2·94m (9ft 8in) Reg. no. 42/20 Photograph by Keith Gibson*

The walls of the spacious COURTYARD surrounding the Warwick Vase form the outer walls of the three rooms from Hutton Castle: Drawing Room, Hall, Dining Room (see pp.24-28, 83-87). Hutton Castle, near Berwick-upon-Tweed, was Sir William and Lady Burrell's home from 1927. These were the most important rooms in the Castle and give a vivid impression of the Burrells' lifestyle. One of Burrell's conditions to the donation of his collection to the City of Glasgow in 1944 was that they should all be reproduced in the new gallery. The rooms are arranged as they were furnished by him in the 1920s and early 1930s with antique furniture, all of it purchased by Burrell from various sources. The rooms also contain the modern furnishings which were specially designed or chosen as a suitable setting for the historic furniture — velvet curtains, window seats and lampshades, chandeliers and

6 The Hornby Castle Portal *English, early 16th century Sandstone, 6·86×2·29m (22½×7½ft) Formerly in the collection of William Randolph Hearst. Reg. no. 44/100*

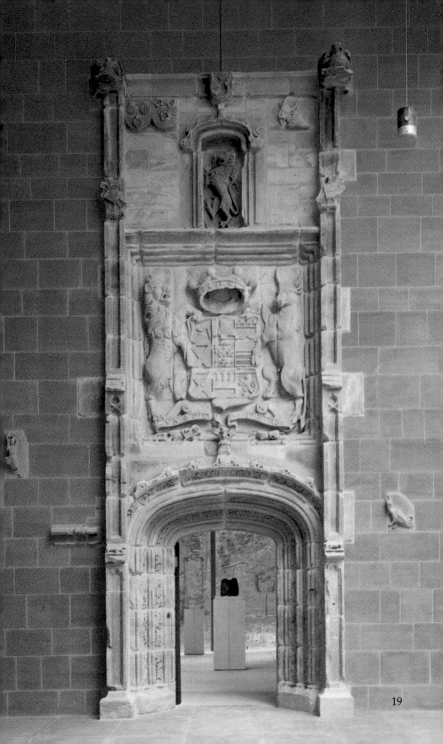

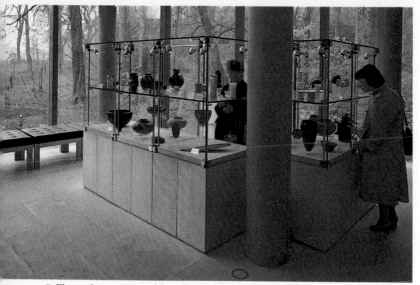

7 *The north-west corner of the gallery, with Egyptian artefacts seen against a woodland backdrop. Photograph by Alastair Hunter*

candelabra, as well as wooden pelmets and radiator fronts appropriately carved in an early 16th-century style. There are details of Hutton Castle on the information board on the north (Courtyard side) wall of the Dining Room.

The walls of the Courtyard are clad in Locharbriggs stone and the pine roof beams and Portland limestone floor slabs and plinths are typical of the high-quality natural materials used in the construction of the gallery. Distributed around the Courtyard and drawn from a wide range of cultures are a few objects which serve as a suitable introduction to the Collection. The centre is occupied by the
5 majestic *Warwick Vase*, which was discovered in fragments at Tivoli near Rome in 1771. It was presented by Sir William Hamilton, the British Envoy to the Court of Naples, to his nephew George, the second Earl of Warwick.

The Vase represents the Ancient World of Greece and Rome; a flavour of the riches of the Oriental art in the Collection (see pp.28-39) is provided by the three Chinese porcelain fish-bowls dating from the late 16th and early 17th centuries A.D., on the north side of the Courtyard. On the east side, beyond the Warwick Vase, are four 12th-century Romanesque capitals set on modern limestone

columns and bases. Two of them are probably southern French; the third is from the south of England and is similar to a fine series of capitals from Hyde Abbey, Winchester. The last capital is either French or Italian.

6 A more dramatic representative of Burrell's medieval interests is the *Hornby Castle Portal*, which formed part of the refurbishments of Hornby Castle in Yorkshire carried out by William, Lord Conyers (1468-1524), and the arch bears the name 'Conyers' below the family arms, a lavish heraldic display typical of the age. It is the largest of a series of imposing medieval stone doorways, arches and windows incorporated into the modern structure. They give the new fabric of the building a sense of age and permanence and also provide a link between the architectural framework and the Collection itself. All the ancient stonework was acquired by Burrell in 1953-4 from the vast collection formed by the legendary American newspaper proprietor William Randolph Hearst and its purchase shows the former's remarkable farsightedness. The large bronze nude statues by **Auguste Rodin** (1840-1917), entitled *The Age of Bronze* and *Eve after the Fall*, speak for Burrell's liking for 19th-century art.

7 Through the Hornby Portal is the NORTH GALLERY and the beginning of the main displays. The north wall of the building is of glass, allowing an exciting interplay between the objects displayed within and the world outside. The works of art take on different qualities through the changes of natural light. In winter they can be starkly silhouetted against a bare landscape and lit by a strong, cold light or low winter sun; in the same season different impressions are imparted by the artificial lighting and the dramatic illumination of the trees and undergrowth. In the autumn they can borrow something of the mellowness and subdued colours of the woodland; in spring and summer the bluebells and foliage provide a backdrop setting echoed by the *verdure* tapestries displayed in the Hutton Castle rooms and Tapestry Gallery.

11 The North Gallery is, therefore, a veritable 'walk through the woods'. By following it the entire length of the building the visitor will pass through all the major areas of the Collection.

The first of these, which is entered from the Hornby Portal, comprises the **ANCIENT CIVILIZATIONS** of Egypt, Greece, Italy, Iraq, Iran and Turkey. This was the last section of the Collection to be formed by Sir William Burrell and the objects in it were mainly acquired in the late 1940s and early 1950s.

Artefacts from **Ancient Egypt** are exhibited in the first area of the North Gallery. The items displayed range from the Predynastic

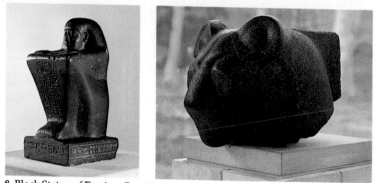

8 Block Statue of Esmin *Egyptian, 26th Dynasty (664-525 B.C.) Granite, height 33·0cm (13in) Reg. no. 13/233*

9 Head of Sekhmet *Egyptian New Kingdom, 18th Dynasty Reign of Amenophis III (1402-1363B.C.) Granite, height 30·4cm (12in) Reg. no. 13/181*

period (*c*.4000-3100 B.C.), to the times of Greek rule in Egypt (the Ptolemaic period, 332-30 B.C.).

Note the series of *shawabtis* in limestone, alabaster and other materials alongside some small sculptors' models and miniature glass bottles. *Shawabti* figures were included in burials to act as substitutes for the deceased if they were called upon to serve in work gangs in the next world. They usually bear the owner's name. Another common type of grave goods was the *stela*, a stone slab inscribed with the name of the deceased and requests for the supply of funerary offerings such as the *stela* of Amenemhet, which dates from the early 18th Dynasty (*c*.1560-1450 B.C.). Nearby is a
8 granite figure of *Esmin* from Karnak. The two cases adjoining the column mainly contain vessels in alabaster, basalt, marble and other hard stones, chiefly of the Predynastic period.

Several of the large sculpture items are mounted on the free-
9 standing plinths; some represent deities, such as the *Sekhmet* who greets you as you enter from the Courtyard, and the bronze statuette of *Osiris*, god of the Underworld; others are of mortals, including the granite relief of the pharaoh *Ramesses II* (1290-1224 B.C.). The quartzite statue of Ramesses' third son, the chief charioteer *Pa-ra-her-wenem-ef*, is interesting for costume details.

There are other objects associated with tombs: the painted limestone relief of a man offering a cup and a goose formed part of the mural decoration of a funerary chamber of the 6th Dynasty (*c*.2420-2250 B.C.), and from the Ptolemaic period comes the monumental head from a coffin lid.

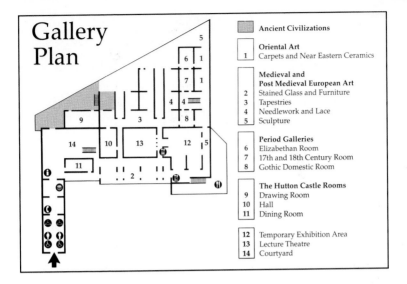

Gallery Plan

	Ancient Civilizations
	Oriental Art
1	Carpets and Near Eastern Ceramics
	Medieval and Post Medieval European Art
2	Stained Glass and Furniture
3	Tapestries
4	Needlework and Lace
5	Sculpture
	Period Galleries
6	Elizabethan Room
7	17th and 18th Century Room
8	Gothic Domestic Room
	The Hutton Castle Rooms
9	Drawing Room
10	Hall
11	Dining Room
12	Temporary Exhibition Area
13	Lecture Theatre
14	Courtyard

The next section in the North Gallery is primarily devoted to **Greek and Roman** items. The earliest Greek pieces include an earthenware Mycenaean stem vase and a small terracotta chariot drawn by two horses, dating from *c.*1250-1200 B.C.. Most are of the 6th and 5th centuries B.C., regarded as the golden age of Greek art. There are some fine examples of vase-painting using both the black-figure and red-figure techniques in cases and on individual plinths. There are *amphora* (storage jars), oil jugs, *kraters* for mixing wine, scent bottles, and two-handled drinking cups, some of them decorated with scenes from classical mythology. Some of the vases in the Collection have been attributed to individual painters. The *lekythos*, or oil jug, is considered to be the work of the **Gela Painter**, who was active from *c.*508 to 485 B.C. in Gela, a town in Sicily founded by Greeks from Rhodes.

From Italy the craftsmanship of the Etruscans is represented by bronze artefacts including a mirror and a fine *cista* (toilet case) with incised decoration of a combat. Typical Bucchero ware pottery is displayed. The Greeks established colonies in Southern Italy represented here by vases from that area mostly in red-figure style, including the *krater* by the Sydney Painter of the 4th century B.C., an excellent piece.

The best known of the Italian cultures is that of **Rome** and a selection of its artefacts is distributed in the cases round the edge of this part of the gallery. On the south wall are glass vessels of

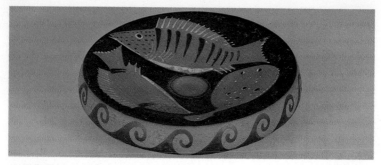

10 Fish Plate *South Italian, red figure, 4th century* B.C. *Earthenware, diameter 18·4cm (7¼in) Reg. no. 19/17*

various types, next to a fine fragment of a floor mosaic depicting a cockerel. The porphyry head of the god *Zeus* or *Poseidon,* a bronze bust of *Hermes* and a marble torso set on the three plinths in front of the glass wall all reveal the debt of ancient Rome to ancient Greece.

The important section concerned with objects from what is now Iraq, Iran, eastern Turkey and Cyprus is encountered in fragments of alabaster reliefs which are displayed against the wall in front of the Mezzanine stairs. The reliefs come from the palaces of the
13 Assyrian kings at Nimrud and Neneveh. Chiefly concerned with military campaigns, they show details of weapons, dress and equipment of the soldiers in the 9th to 7th centuries B.C. Passing through the late 13th century French limestone doorway with two small wall cases containing Mesopotamian seals and armlets, the adjoining area is devoted to antiquities of Western Asia. Displayed here are objects associated with the Sumerian and other early cultures of South Iraq. There are alabaster votive statuettes which were placed in the sanctuary of a religious building to intercede with a deity. Note the life-size terracotta head of a lion, probably from a temple, and belonging to the **Isin-Larsa** period *c.*2000-1800 B.C.

Metalwork from Luristan in the Zagros Mountains of Iran comprises of a number of finials, horse bits and other bronze artefacts which show the skill of the craftsmen. Alongside are Cypriot objects: jugs, amphora and statuettes. One of the most
14 intriguing pieces is the fine bull's head from Urartu, which was contemporary with the Assyrian empire. The head, originally one of four, decorated the rim of a large bronze cauldron supported on a tripod.

From the Ancient Civilizations you can enter the DRAWING

11 *The North Gallery looking east. Photograph by Alastair Hunter*

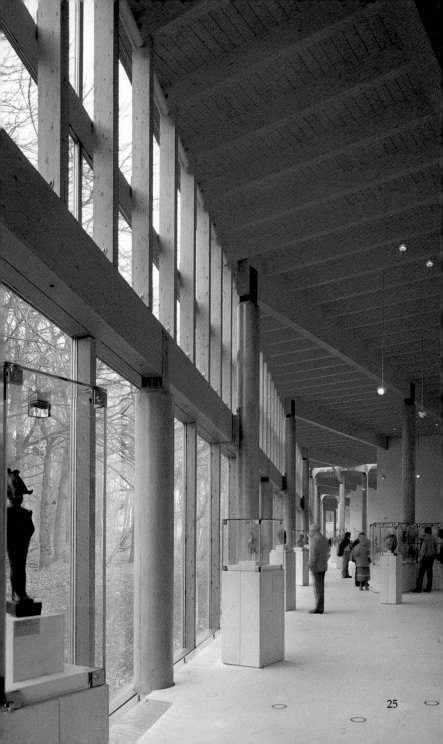

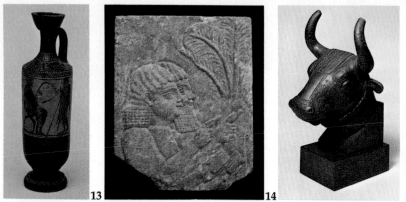

12 Lekythos *Greek, Attic black figure, c.500 B.C. Earthenware, height 25·0cm (9⅞in) Reg. no. 19/95*

13 Scribes Recording on Waxed Writing Boards *Assyrian relief, period of Sennacherib-Ashurbanipal (704-627 B.C.), probably from the S.W. Palace of Kuyunjik (Nineveh), Iraq. Alabaster, 18·2×15·0×1·5cm (7⅜×5⅞×⅝in) Reg. no. 28/33*

14 Bull's Head Cauldron Attachment *Urartian, probably from Toprak Kale, Lake Van, Turkey, 7th century B.C. Bronze, height 14·3cm (5⅝in) Reg. no. 33/212*

15 ROOM from Hutton Castle. The Drawing Room is the largest of the three Hutton rooms and was Burrell's main display area for tapestries and stained glass. The first window from the left contains two 15th-century angels holding shields of arms from the chapel of the former Hospital of St John at Northampton, as well as several small English heraldic panels. In the two main lights of the centre window is a French early 16th-century *Annunciation*, with small shields of arms and roundels above and below. The lights at the top contain a medley of 14th and 15th-century English glass. The chief elements of the right-hand window are the full-length figures of *St Peter* and an *Archbishop-saint*, surmounted by two angels, painted in East Anglia. At the top are figures of a female saint and a bearded donor. The ancient glass in the west window is confined to the three small lights and comprises two late 15th-century panels with the arms of Howard, Duke of Norfolk, and of the Vere Earls of Oxford, separated by a French roundel depicting the *Annunciation* and the cleric who was its donor.

Between the windows facing into the Courtyard are two early 16th-century **Franco-Flemish tapestries** from a set of the Labours of the Months, thought to be a product of the Tournai workshops of

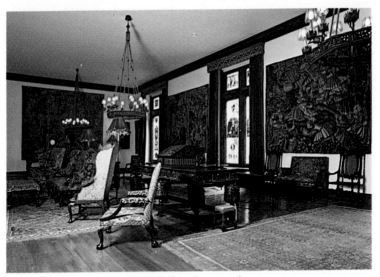

15 *The Hutton Castle Drawing Room from the west end.*

16 **Arnoult Poissonnier.** The first, for *January*, depicts a man, probably personifying the month, seated before a roaring fire being plied with food and drink whilst outside a primitive form of golf or hockey is in progress. The companion tapestry illustrates the activities associated with the month of *September*, with huntsmen setting ferrets to catch rabbits; in the background a peasant casts seed on a ploughed field. Two more Franco-Flemish hangings in this room belong to the type known as *millefleurs* because of their multi-flowered backgrounds. One of these shows *Johannes von Schleinitz*, Bishop of Naumburg (1422-34), and probably formed part of a series depicting bishops of this see woven in the period 1525-50. The second (viewed from the west door) depicts *Charity overcoming Envy* and almost certainly belonged to a large set depicting a series of battles between the Seven Cardinal Virtues and the Vices mounted on allegorical animals. Two of the remaining tapestries displayed at the west end of the room bear the arms of William III of Beaufort, his wife Eleanor of Comminges and their son Raymond, Vicomte de Turenne. They were almost certainly commissioned by William, who married Eleanor in 1349.

The other textiles in the Drawing Room consist of **Persian and Caucasian rugs and carpets** mainly of 19th-century date, and needlework and tapestry coverings on various chairs and settees.

The **furniture coverings** are all English, of the period *c.*1690-*c.*1760, supplemented by several contemporary Netherlandish cushions. The **furniture** is chiefly oak and walnut, dating from the 17th century. Near the large Late Gothic stone fireplace and chimneypiece is an unusual *clock* with wing pieces to allow wider oscillation of the pendulum. The movement is for a duration of 30 hours and the case is decorated in red lacquer with *chinoiserie* motifs.

On the tables and in the two wooden niches on the east wall is some interesting **medieval sculpture,** most of it late 15th or early 16th-century Netherlandish or German. The tall group of *St Anne holding the Virgin and the Child Christ* in front of the large tapestry on the east wall is a notable example of south German limewood carving.

After the Ancient Civilizations comes **ORIENTAL ART.** With 2000 items, this is numerically the largest section of the Collection. It is particularly strong in Chinese ceramics and bronzes, and is one of the most important collections in the British Isles in these fields. Precisely what sparked off Sir William Burrell's taste for Far Eastern art is unknown, but his interest was aroused at quite an early stage in his collecting career. By the early years of the 20th century he already owned Chinese ceramics and the Purchase Books record that he acquired in this area almost every year between 1911 and

16 Tapestry Depicting the Month of January *Franco-Netherlandish, early 16th century Wool, 271·7×320cm (107×126in) Reg. no. 46/75*

17 Miniature Long-Case Clock *(detail of upper section) English, inscribed 'Markwick Markham Perigal London', 18th century Lacquered wooden case, 167·7×11·4cm (66×4½in) Formerly at Cold Ashton Manor, Gloucestershire, Reg. no. 10/5*

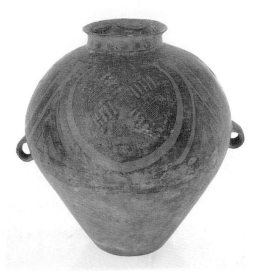

18 Neolithic Painted Urn *Chinese, Yangshao culture, 3rd millenium B.C. Earthenware, height 30·4cm (22½in) Reg. no. 38/12*

1957. His most prolific period of activity was 1945-8 when he bought more than 120 pieces per year, including some of the best items in the Collection. Burrell had a particular liking for early ceramics.

Indeed, the earliest examples of the craft of the Chinese potter are perhaps the most astonishing, to contemporary eyes. We have to remind ourselves that the balanced forms of the earthenware vases, with their vigorous painted decoration of darker brown hues on the mid brown bodies, are **Neolithic:** mortuary urns or jars dating from 3000 to 2000 B.C. Associated with the Neolithic Yangshao culture which was centred on Gansu province in the north west but also spreading eastwards into Shaanxi and Henan, the making of such pottery artefacts was evidently an important and established activity in China, even at this early date. In typical examples, the decoration covers only the upper half of the urn with mainly geometric motifs. Animal, fish and even human forms can occasionally be identified.

Displayed alongside are **bronzes**, which appealed very much to Burrell for their patina (the colouring built up by years of burial). Indeed, although there are less than 200 Chinese bronzes in the Collection, on the whole he preferred them to ceramics. Bronzes are

amongst the first items recorded in Burrell's Purchase Books and the last of them were acquired after the Second World War.

Like jade, bronze is a material which has been worked by the Chinese for centuries. The early craftsmen were renowned for the variety of elegant forms and intricate decoration they produced. Bronze items dating from as early as *c*.2300-2000 B.C. have been discovered in China, but cast-bronze objects only appeared in any number several centuries later. The bronze-caster's art reached its height during the Shang and Zhou Dynasties (16th-11th centuries B.C. and 11th-3rd centuries B.C.) and it is from these periods that most of the bronzes in the Collection date. Most of them are *vessels* used in ritual sacrifice, especially to ancestors, and were made to contain either food, water or, as in the illustrated

20 example, wine. Many have inscriptions giving the family name of the owner or identifying the deceased person and they are usually elaborately decorated. The creative fertility of the craftsmen is demonstrated by the many different forms of the vessels displayed here.

Not all of the exhibited items are food or liquid receptacles. There is an interesting group of early *bells* of the Zhou Dynasty; they have no clappers and are played by striking with a bronze or wooden hammer. The Zhou and Han Dynasties also saw the production of some elegant weapons, horse trappings and chariot fittings.

19 Sir William Burrell's collection of **jades** was mainly formed in the 1940s. It numbers only about 140 pieces, but they span a very wide range, from the Neolithic period to the last imperial dynasty, the Qing (A.D. 1644-1912), and they encompass an equally wide variety of objects: ornaments, weapons, items for ritual use, humans and animals. Jade has always been valued by the Chinese as a very special material. In Neolithic times it was highly prized for its hardness which made it very suitable for tools and weapons — the blades of several of the exhibited halberds and axes dating from the late Shang Dynasty (13th-11th centuries B.C.) are jade. Several *pendants* from the same period are carved in the forms of birds and fish. Amongst the later jades displayed here are some very elegant *vases* and *bowls*. The markings of the original stone vie for attention with the surface decoration and shapes of these vessels.

In the North Gallery are some of the most important and attractive of the **Chinese Ceramics and Bronzes**, in addition to a few sculptures and a fine 16th-century *cloisonné* enamelled dish. The earliest items are the large bronze *lian*, or cylindrical box with ring handles and three legs in human form, the earthenware lead-glazed *watchdog* and the model of a *storehouse*, all of which date from

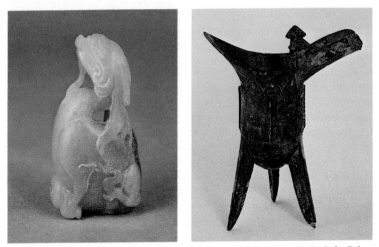

19 Seated Mythical Animal *Chinese, Ming Dynasty* (A.D. 1368-1644) *Jade, 7·6cm (3in) Reg. no. 22/52*

20 Jue (ritual vessel) *Chinese, Shang Dynasty, 13th-11th century B.C. Cast-bronze, 18·1cm (7⅛in) Reg. no. 8/15*

the Han Dynasty (206 B.C.-A.D. 220); the last two were made specifically for burial with the dead. The watchdog in his carefully detailed harness was intended to protect his master in the next world. The storehouse, complete with figures carrying sacks, is very important for the information it provides about early Chinese architecture. Ceramic grave goods reached a peak of magnificence during the Tang Dynasty (A.D. 618-907) with the splendid horses and camels and elegantly dressed figures. An example of each of these can be seen in this area, all made with the *sancai* or three-colour glaze of green, amber and cream. The trappings of the horse reflect Persian Sassanian influence and the male attendant figure in the same showcase wears Central Asian dress. The face and neck of this attendant are unglazed and painted with unfired pigments, a characteristic treatment for human or semi-human figures in this period. It also appears on the pair of figures with fierce expressions standing at the entrance to the ORIENTAL DAYLIT GALLERY, where they perform something like their original function as guardians of tombs against evil spirits. They are representatives of the spirit world in exaggerated human form and are known as *fangxiang* figures.

Nearby are some very fine Chinese porcelains from the Yuan and early Ming Dynasties, with underglaze cobalt blue and copper-red decoration. These underglazes were introduced in the 14th century by the potters of Jingdezhen in the province of Jiangxi: many of the wares, such as the large dish and tankard, were made for the Near Eastern market and are based on designs from this region. The splendid copper-red *ewer* derives its shape from a Near Eastern metalwork vessel and includes decorative motifs of Near Eastern origin, although the latter are combined with Chinese traditional designs.

Very different from the Ming porcelains are the monumental **21** seated figures near the North Wall of a *Lohan* (disciple of Buddha), dated 1484, and of an official, which was made in 1609. Both are stoneware with overglaze enamel decoration in colours similar to that of the nearby Tang pieces. An excellent vista can be obtained from the Lohan looking down the Oriental Daylit Gallery and through to the stained glass on the south side of the building.

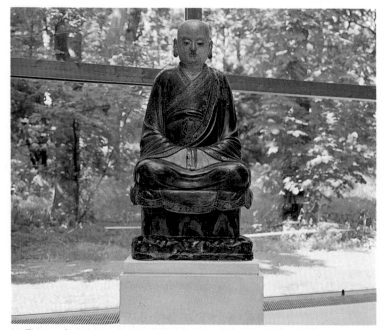

21 Figure of a Lohan *Chinese, Ming Dynasty, inscribed 20th year of Chenghua (A.D. 1484) Stoneware with polychrome on biscuit glaze and traces of gilding, 126·8×66·7×43·2cm (50in×26½in×17in) Reg. no. 38/419*

23 The **Chinese ceramics** in the Oriental Daylit Gallery and in the CORRIDOR beyond are wide-ranging in type, form, material and in date. Note, for example, the attractive Han Dynasty *grave goods*, including a pair of owls and two cockerels, as well as a pair of guardian figures from the Six Dynasties period, and the ceramic models from tombs, this time of the Tang Dynasty period. The vivid and dramatic poses of the acrobat and the horse fiercely pawing the ground can be contrasted with the gentler pursuits of music-making and with the set of five very slender servants carrying various objects. The very beautiful *ding* wares of the Song Dynasty (A.D. 960-1279) have either incised designs or moulded decorations, according to their date of manufacture. Both incised and moulded patterns can be seen on the *ginghai* wares (porcelain with a slightly bluish glaze) dating from the Yuan Dynasty (A.D. 1260-1368). The *black wares* from Henan province are exceptional;

22 note also a series of tea bowls demonstrating the range of decorative motifs used on black glazes: speckled, splashed, streaked and those based on paper-cuts. All these date from the 12th to the 14th centuries A.D. A particularly attractive piece is the model of a *recumbent tiger*, made during the Song Dynasty.

Amongst the most popular of Chinese ceramics is the green-glazed stoneware known as *celadon*. The ware was first made in the 9th century A.D., but it was not fully established until the following century and reached its peak during the Northern Song Dynasty

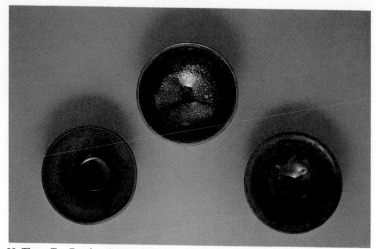

22 Three Tea Bowls *(1) North Chinese, Northern Song-Jin Dynasty, 12th-13th century A.D. Stoneware, slipped and glazed with splash decoration, 4·5×12·4cm (1¾×4⅞in) Reg. no. 38/347*
(2) North Chinese, Henan Province, Jin Dynasty 12th-13th century A.D. Stoneware, slipped and glazed with speckled effect, 5·4×12·7cm (2¼×5in) Reg. no. 38/348
(3) Chinese, Fujian Province, Southern Song Dynasty, 12th-13th century A.D. Jian ware, stoneware with viscous black blaze with 'hare's fur' effect, 5·1×12·1cm (2×4¾ in) Reg. no. 38/359

(A.D. 960-1126). From this time celadon wares have been much admired in China and are still made there today. Nearby are porcelains with underglaze cobalt blue decoration, from the Ming and Qing Dynasties. Near Eastern shapes and motifs are well to the fore on several of the vessels, including the *meiping* vase with Arabic inscriptions. Many of the later blue and white wares have scenes or figures. That on the large *rouleau* vase depicts the Emperor on his pleasure barge. Not only blue and white porcelains were produced during the Ming and Qing Dynasties, as is shown by the selection of the *monochrome* (or single glaze) *porcelains* in various colours, including copper-red, ox-blood, peach-bloom and yellow (the Imperial colour). The peach-bloom vase and the beehive-shaped water pot were made for a scholar's table. Other **24** vessels concerned with writing include a charming *water pot* in the shape of a tree shrew and a *brush rest*; the latter is embellished in enamels on biscuit porcelain. During the 16th century overglaze enamel decoration became popular in China. Sir William Burrell

23 *The Oriental Daylit Gallery on a winter evening. Photograph by Alastair Hunter*

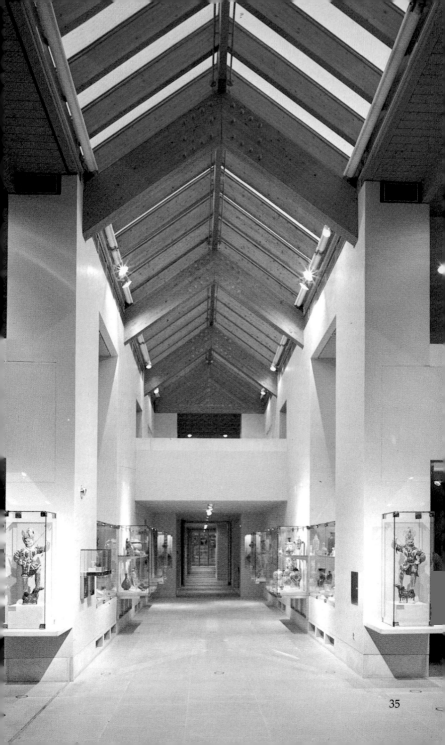

24 Water Pot *(in the form of a tree-shrew)* *Chinese Kangxi period (1662-1722)*
Porcelain, length 8·5cm (3⅜in) *Reg. no. 38/862*

particularly liked the wares with *famille verte* enamels and there are
a large number in the Collection.

The *conical bowl* in one of the pair of small wall-mounted
showcases at the end of the Gallery is amongst the rarest pieces in
the entire Collection. It is an example of a particular Korean variant
of the celadon wares and is painted with copper-red decoration
under the celadon glaze. This bowl dates from the Koryo Dynasty
(12th and 13th centuries A.D.).

The Oriental collections continue in the East Gallery which is
devoted to a selection of **CAUCASIAN, INDIAN AND PERSIAN
CARPETS** of the late 16th to 19th centuries. Most have a woollen
pile, but some are silk. Amongst the earliest is the fragment of an
Indian animal carpet. It is the largest surviving fragment of what
must have been a magnificent carpet, formerly in the collection of
the Holy Roman Emperors in Vienna. It depicts a wide variety of
flowers, animals and birds, both real and fantastic. Mythical beasts,
this time dragons, are the chief element in the design of a large
Caucasian carpet. This particular carpet dates from the 17th century,
when the dragon designs were at their finest. *Hunting carpets* show
a naturalistic treatment of the animal world. Large Persian carpets
often had a design based on formal ornamental gardens, complete
with a central pool, waterways containing fish, paths, trees and
flowers. The *Wagner garden carpet,* which can normally be seen in
the Hutton Drawing Room, is amongst the finest garden carpets in
existence, and another sometimes hangs in the East Gallery.
Carpets are notoriously difficult to date, as is illustrated by one of
the largest in the Collection. It is named after a previous owner,
Prince Alexander Dietrichstein, and traditionally is said to have
been given to the Empress Maria Theresa of Austria (1717-80) by the

25

then Shah of Persia. Recent research, however, suggests that the carpet is no earlier than the 19th century. Its splendid condition and design make it one of the most attractive carpets in the Collection.

Alongside the carpets is a selection from the **Islamic Prayer Rugs**. These are all quite small, usually less than two metres in length, and although they can be displayed as wall-hangings they were — and still are — used in the Muslim world to cover the floors of mosques and by the devout to kneel on and face Mecca during the required periods of daily prayer. The prayer rugs in the Collection come from the Anatolian heartland of Turkey, Persia (Iran) and the Caucasus (present-day southern USSR) and mainly date between the 17th and 19th centuries. Though varying from region to region, most of the rugs have in common a representation of the *mihrab*, the prayer niche in a mosque wall which indicates the direction of Mecca. The earliest of the Islamic carpets in the Collection is the *fragment* from the border from one of two carpets formerly in the mosque of Ardabil in Persia, of which various segments are scattered in museums around the world. These carpets are dated by inscription to the Muslim year 946 (A.D. 1539-40) and were made for the shrine of Sheikh Safi, the founder of the Safavid Dynasty. Also in the Collection is a fragment of another Persian carpet, of the 18th century, and a very fine section from the border of an *Indian animal carpet*. The latter is very finely woven with fishes and the heads of horses, lions and oxen in a lattice-work of plant sprays.

The associated showcases contain a selection from nearly 300 items of **ISLAMIC METALWORK AND CERAMICS**, a field in

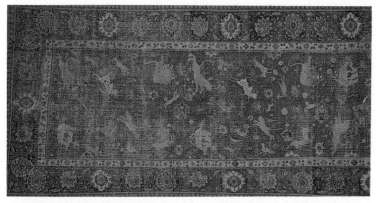

25 Hunting Carpet *Indian, 17th century* A.D. *Woollen pile, cotton warps and wefts, 475×170·2cm (16ft 7in×6ft 7in) Formerly in the collection of the Earl of Mount Edgcumbe. Reg. no. 9/32*

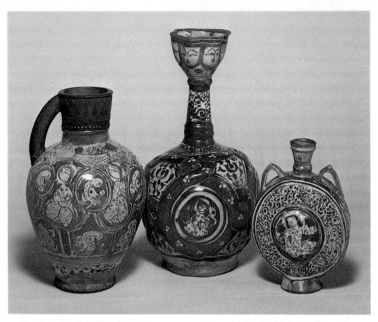

26 Bottle *Persian, 12th-13th century* A.D. *Fritware glazed with lustre decoration, height 35cm (13¾in) Reg. no. 33/124*
Pilgrim Flask *Persian, 12th-13th century* A.D. *Fritware glazed and decorated with lustre, height 20·6cm (8⅛in) Reg. no. 33/158*
Jug *Persian, 13th century* A.D. *Fritware with underglaze blue and lustre decoration, height 28cm (11in) Formerly in the collections of I. E. Taylor and E. L. Paget. Reg. no. 33/168*

which Burrell collected seriously only in the last ten or eleven years of his life. The artefacts range in date from the 9th to the 17th centuries and come from an area stretching from modern Turkey in the west to Samarkand in the east. Those on display demonstrate the variety of techniques used by the Near Eastern potters, including pieces of the 9th and 10th centuries from Khurasan and Transoxiana, and the Garrus area of north-western Persia. Nearby are examples of 12th and 13th century Persian fritware.

The influence of China was always strong on Near Eastern potters; from the Tang Dynasty (A.D. 618-907) onwards Chinese ceramics were imported into the area and imitated. Sometimes direct copies of Chinese prototypes were produced, such as the **26** green fritware dish decorated with fishes, made in Persia in the 13th or 14th century. Some 17th-century *porcelains* with underglaze

blue decoration are similar to the pieces from the Ming and Qing Dynasties displayed in the Oriental Daylit Gallery. One bowl even has figures wearing Chinese-style clothes and placed in a landscape with pagodas. The **Turkish pottery** industry which flourished at Iznik (ancient Nicaea) between the 15th and 17th centuries made use of both Chinese decorative designs and Islamic elements, often combined together on the same vessel.

Returning to the North Gallery, the remaining areas are concerned with decorative arts from the **MIDDLE AGES AND NORTHERN RENAISSANCE**. The art of the period *c.*1300-1530 was always Sir William Burrell's first love, as is apparent from the contents of the reconstructed rooms from Hutton Castle.

Burrell's interest in the Middle Ages was aroused at an early age and continued to the end of his life. It may be significant that his schooldays were spent in St Andrews, where there are evocative remains of important medieval buildings; as a young man he was also well-acquainted with the medieval castles in the East Neuk of Fife. By the turn of the century he had purchased a representative range of medieval artefacts, including tapestries, items for ecclesiastical and domestic use, and sculptures in wood, alabaster and ivory.

Even within the confines of the medieval period Burrell had his likes and dislikes; it was only with considerable difficulty, for instance, that he could be persuaded to buy pieces earlier than the 14th century. It is somewhat ironic, therefore, that some of the most highly valued medieval items in the entire Collection date from before 1300. A number of these pieces are on display in a room fronted by the large free-standing *English arch* of *c.*1200, carved with a profusion of rosettes and geometric shapes.

There is a selection of small medieval objects — ivories, Limoges enamels and bronzes dated from the 12th to the 14th centuries. Pride of place perhaps goes to the *Temple Pyx*, a small bronze-gilt group of three sleeping knights almost certainly representing the soldiers at the Holy Sepulchre and originally forming part of a 12th-
27 century English shrine or reliquary. The *ivory draughtsman* is of the

27 Draughtsman *German, late 12th century Ivory, diameter 5·7cm (2¹⁄₅in)*
Reg. no. 21/2

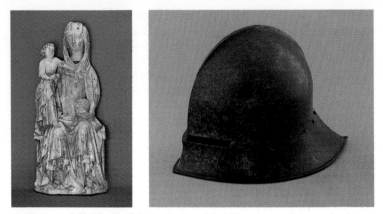

28 Virgin and Child *English, Nottingham, late 14th century* *Alabaster, height 46·3cm (22½in)* *Reg. no. 1/19*

29 Sallet *South German, Augsburg, c.1480* *Steel, 22·8×37·4×22·2cm (9×14¾×8¾ in)* *Formerly in the collection of Morgan S. Williams.* *Reg. no. 2/10*

same epoch. Other particularly noteworthy pieces include the enamelled reliquary *châsse*, or casket, made at Limoges, in *c.*1200-10, on which is depicted the martyrdom of Thomas à Becket and an early 14th-century German bronze *aquamanile* in the form of a lion from Brilon in Westphalia. Aquamaniles, as the Latin name suggests, held water and were frequently used in church services, but as this example bears Hebrew inscriptions they were not exclusively confined to Christian use.

Most of the medieval pieces in the Collection come from northern Europe, but against the south wall of this room is a group of large Spanish objects. The effigy on the tomb, resplendent in chain mail and an elaborately decorated surcoat, represents *Don Ramon Peralta de Espès* (d.1348), Captain-General of the armies of the kingdom of Aragon and Grand-Admiral of Aragon and Sicily. This monument, which retains much of its original painted decoration, comes from the monastery of Santa Maria de Obarra at Calvera near Huesca in northern Spain. The painted wooden figures of the *Virgin* and *St John* above the tomb are probably from the same region but are somewhat earlier, dating from the late 13th century. They originally formed part of a Crucifixion group.

Other items in the room worthy of a close study are the highly
28 important *Virgin and Child* in alabaster and, on the opposite wall, the *Bury Chest* — one of a very rare group of English oak coffers with painted heraldic decoration. It comes from the Chancery Court

of the Palatinate of Durham and was made during Richard de Bury's reign as Bishop of Durham (1334-45). He was much employed in the service of the English crown and was noted for his fine library, splendid retinue and sumptuous living.

The vestment in the freestanding showcase is a *dalmatic*, which was worn by deacons at Mass. It has two wide strips known as orphreys embroidered with scenes from the early life of the Virgin and her parents Joachim and Anne. These scenes are of great charm, none more so than that of the Virgin taking her first steps with the aid of a wooden baby-walker, watched anxiously by her mother and father. The dalmatic is Italian, and the orphreys are an example of English needlework known as *opus anglicanum*, which was justly admired throughout western Christendom. The vestment forms part of a set said to have belonged before the Reformation to the Cistercian abbey of Whalley in Lancashire.

In the area in front of the glass north wall are some notable works of **medieval sculpture**. The small-scale delicacy of the boxwood *Virgin and Child* of *c.*1325-50 may be contrasted with the more monumental treatment in limestone of the same subject and of a female saint. Together with the *Head of the Virgin* they reveal the quality of French Gothic sculpture of the period 1250-1350. The large *Virgin and Child* statuette in front of one of the columns was originally painted and retains two of the glass inserts imitating jewels in the hem of her robe.

Guarding the entrance to the EUROPEAN DAYLIT GALLERY are two early 16th-century *South German armours*. The simplicity and functional nature of that on the right, made for the battlefield, is in contrast with the elaborate etched decoration of its companion, designed for ceremonial or tournament use. The latter is a composite, made up of elements from various suits; the most important sections were made by a leading armourer, **Michael Witz** of Innsbruck, for the Emperor Ferdinand I (1503-64). The martial theme continues in the cases in the European Daylit Gallery, which contain a selection of armours and weapons, including a series of swords dating from *c.*1200 to the early 16th-century. The hilt of the *Coventry Civic Sword* is the most important historically and the etched decoration on the Milanese half armour of *c.*1570 is particularly fine. The Augsburg *sallet* is probably the most outstanding of the helmets. The only firearm in the Collection is the Scottish *pistol* dated 1649.

The remainder of the European Daylit Gallery beyond the pair of limestone windows is devoted to a changing selection of **European decorative arts** from the 14th to the 18th centuries. The Burrell

29

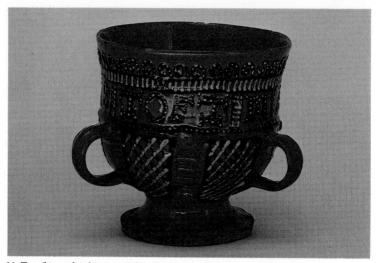

30 Tyg (large drinking vessel) *English, Staffordshire, c.1675* *Earthenware, height 16·5cm (6½in)* *Reg no. 39/92*

Collection is not generally known for its European *ceramics*, but there are some very fine examples of tin-glazed earthenware, particularly those made in Valencia, Spain, in the period *c* .1430-1550. The eye-catching gold-lustre decoration of these dishes is very different from the English *slipware* (a style of decorating the earthenware with a diluted clay of a different colour) made in Staffordshire during the late 17th and early 18th centuries. Two of Sir William's slipware pieces are 'signed' by **Thomas Toft**, one of the leading potters of the period. The German stoneware jugs and tankards are notable for their heraldic decoration. Heraldry also plays its part in the decoration of some of the large *pewter plates*, or chargers, which have some of the naivety and simplicity of their slipware counterparts. One dated 1677 commemorates the reconstruction of the City of London following the Great Fire of 1666 by a phoenix rising from the flames and a bust of King Charles II.

The delicacy of the *table glass* and *silverware* contrasts strongly with the vigour of the pewter and pottery. The outstanding craftsmanship of the Dutch engravers of the 18th century is seen in the Dutch, English and German wine glasses and goblets. Two showcases contain *glassware,* unengraved except for a large English goblet commemorating the battle of Trafalgar in 1805.

The Collection contains nearly 300 silver items, mostly English, of

30

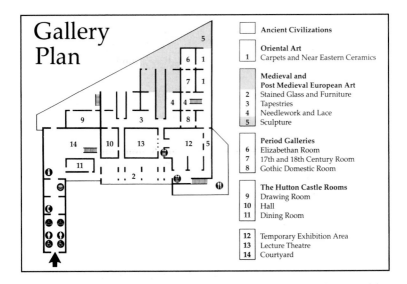

Gallery Plan

	Ancient Civilizations

Oriental Art
1 Carpets and Near Eastern Ceramics

Medieval and Post Medieval European Art
2 Stained Glass and Furniture
3 Tapestries
4 Needlework and Lace
5 Sculpture

Period Galleries
6 Elizabethan Room
7 17th and 18th Century Room
8 Gothic Domestic Room

The Hutton Castle Rooms
9 Drawing Room
10 Hall
11 Dining Room

12 Temporary Exhibition Area
13 Lecture Theatre
14 Courtyard

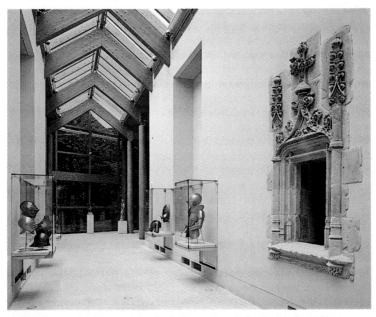

31 Window in the European Daylit Gallery *French, late 15th early-16th centuries* Limestone, height 289·5cm. (9ft 6in) *Formerly in the collection of William Randolph Hearst.* Reg. no. 44/91

17th and 18th-century date and include tankards and other drinking vessels, spoons, salvers, plates and candlesticks. There is a fine *toilet set* in its original container made for the Hurst family of Lincolnshire. Burrell's taste is evident in the comparatively simple decoration of the silver; for him the work of the Huguenot (French Protestant) goldsmiths who settled in England in the late 18th century was too elaborate. There is, however, one outstanding example of Huguenot engraved silver in the Collection, the *salver* made for the Earl of Halifax. Another interesting historical item is a silver-mounted *coconut cup* dated 1662 carved with scenes illustrating the escape of King Charles II after the battle of Worcester.

31 In the European Daylit Gallery, the pair of *limestone windows* provide an attractive framework for a view into the MEDIEVAL ROOMS which flank this space. One of these rooms is entered via the large free-standing *sandstone arch* which forms the entrance. The high-relief carved decoration on this portal includes some amusing scenes of wrestling monkeys, birds, a cat, thistles and youths picking acorns. The presence of palm trees indicates that the arch must come from a Mediterranean country, probably Spain or Portugal. It dates from the early 16th century.

The second Medieval Room is devoted almost entirely to objects and furnishings used in the Church during the Middle Ages. The most complete item of furniture is the set of canopied *choir*
32 *stalls* with three *misericords*, hinged seats with projecting ledges on the underside which when tipped up provided a support for the clergy during the lengthy services. These ledges allowed the medieval carver to give full rein to his creative imagination. The six misericord seats mounted on the east wall demonstrate the wide range of designs used: animals, monsters, human figures and heads, and Noah's Ark.

One of the richly-embellished *stall-ends* depicts a prophet and angels and is of late 15th-century southern Netherlandish origin. The presence of St Quirinus, whose shrine was at Neuss in the Lower Rhineland, suggests that the companion stall-end comes from this region. It may be the work of a sculptor named **Heinrich Bernts** (d.1509).

The English late medieval wood-carver was as uninhibited as his continental counterpart. Appropriately, angels were a common subject in the decoration of English church roofs and there is a set of four above the six misericords on the east wall. They are playing a variety of musical instruments, including the clarion, tabor and shawm and date from the late 15th or early 16th century.

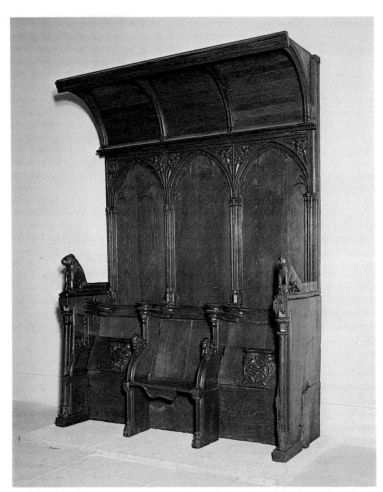

32 Choir Stalls *French, c.1450-1500* *Oak, 299·7×97·0×76·2cm (9ft 10in×7ft 5in×2ft 6in)* *Formerly in the collection of William Randolph Hearst.* *Reg. no. 14/5*

Tombs and monuments formed a major element in the furnishings of medieval churches. The three angels holding shields and enclosed within niches come from one side of a late 15th-century *alabaster tomb chest* of a type widely distributed in England. Tombs were not always made of stone and alabaster; frequently the deceased was commemorated by a monumental brass set into a slab in the floor such as the three *brasses*, the most impressive of which

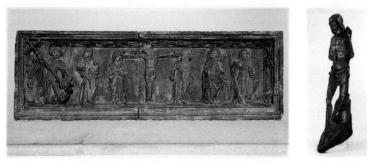

33 Burgundian Altarpiece *French, c.1450-1500 Painted limestone, 86·3×177·8cm (2ft 10in×5ft 10in) Reg. no. 44/36*

34 Figure of Christ *South Netherlandish, late 15th century Painted oak, height 51·4cm (20¼in) Reg. no. 50/21*

commemorates the historian and mapmaker John Speed (1542-1629). The majority of the objects in these two showcases formed part of **altar furnishings** or were used in church services. They include large brass altar *candlesticks*, altar and processional *crosses* (one of which is a very rare example in rock crystal, dating from the 13th century), *chrismatories* used to contain the holy oils for Baptism, Confirmation and Extreme Unction and receptacles for the Sacramental bread (the Host) known as *pyxes* or *monstrances*. The *chalice* was the most elaborate of the liturgical vessels; one of those displayed here is made of silver, partly gilt, with translucent enamelling, and most unusually has the embossed figures of the donors, George and Margaret Sperling, kneeling before the Virgin and Child. It was made in northern Germany in the late 14th or early 15th century. In the centre of the room is an impressive English *chasuble* and, on the north wall, two very important *tapestry fragments,* which are related to the famous Apocalypse series at Angers, France.

The ecclesiastical theme continues in the North Gallery, where there is a major display of retables or **altarpieces**, the dominant
33 sculptural form of the 15th and early 16th centuries. The *Burgundian altarpiece* has been placed on an imitation altar to give the impression of the original setting of such retables. The figures on it bear witness to the long-lived influence of Claus Sluter, the Netherlandish-born carver who in the years around 1400 established a distinctive school of sculpture in Burgundy. As can be observed from the examples shown here, the design of retables varied considerably in northern Europe. The most elaborate and attractive were the limewood altarpieces of southern Germany and

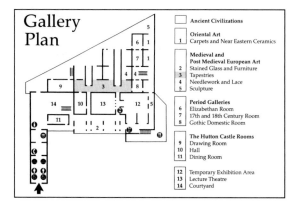

Gallery Plan

	Ancient Civilizations
1	Oriental Art Carpets and Near Eastern Ceramics
	Medieval and Post Medieval European Art
2	Stained Glass and Furniture
3	Tapestries
4	Needlework and Lace
5	Sculpture
	Period Galleries
6	Elizabethan Room
7	17th and 18th Century Room
8	Gothic Domestic Room
	The Hutton Castle Rooms
9	Drawing Room
10	Hall
11	Dining Room
12	Temporary Exhibition Area
13	Lecture Theatre
14	Courtyard

those from the Tyrol, which were made of pine. Although there is no complete altarpiece from these regions in the Collection, it does include various components from them, such as the large early 16th-century *Lamentation over the dead Christ* which almost certainly formed the centrepiece of a retable from the Augsburg area. Painted altarpieces continued to be made in Germany well into the 1520s, but from the 1490s an alternative appeared in the form of the monochrome, or unpainted retable, which enabled the sculptor to carve very fine details; the limewood *Nativity* from the wing of a Franconian altarpiece of *c.*1500 is a good example of this. Late medieval altarpieces in England usually consisted of a row of alabaster panels depicting scenes from the life of Christ and/or the Virgin, and of individual saints, enclosed within a wooden framework. The panels displayed in the long case on the south wall come from various dismembered altarpieces. The English alabaster carvers also made individual cult images, such as the majestic *Holy Trinity* of 1375-85, set high on the wall over the Burgundian altarpiece. Alabaster was also used, indeed more proficiently, by sculptors in France, Germany and the Netherlands. The small *Pietà* in front of the Burgundian altarpiece can be attributed to the workshop of the **Rimini Master**, a highly accomplished artist who seems to have settled in the Middle Rhine area of Germany between *c.*1420 and 1430. The *Virgin and Child* set against the glass wall is a fine example of late 15th-century Netherlandish alabaster work. In front of the column in the middle of this space is a monumental limestone figure of *St Margaret of Antioch;* the delineation of the brocading on her dress and the hem decoration are characteristic of early 16th-century French sculpture. Notice the series of small late medieval wooden sculptures from Germany,

Austria and the Netherlands. Some are individual devotional statuettes, such as the attractive painted and gilded *Virgin and Child* **34** from Malines near Brussels. Others, like the *Figure of Christ*, come from altarpieces. This originally formed the centrepiece of a Flagellation scene on a retable devoted to the Passion of Christ.

As you move towards the heart of the building, you enter the **35** TAPESTRY GALLERY, the main area in the building for the display of some of Burrell's world-ranking collection of over 150 tapestries, ranging in date from the 14th to the early 16th century, and representing all the major centres of production in this period. Sir William Burrell always considered that the tapestries were the most valuable part of his collection. Although he bought tapestries throughout his collecting life, most of the outstanding acquisitions were made in the late 1920s and 1930s.

The space has been arranged so as to give the impression of a Great Hall in a late medieval mansion or castle, and an architectural setting is provided at the east end by the *limestone doorway* which gives access to the Gothic Domestic Room (this doorway belongs with the limestone arches in the European Daylit Gallery). Further, the centre section and west bay are overlooked by three early 13th-century *limestone arches* which belonged to a house in Provence (see p.56). The painted *Beaudesert Screen* in the east bay, near the limestone doorway, comes from the great hall at Beaudesert in Staffordshire, a residence of the Bishops of Coventry and Lichfield before the Reformation.

The Tapestry Gallery also contains **oak furniture** and displays of weapons. The former includes, in the centre section, an early 16th-century *canopied bench* with the arms of the Earl of Ormonde and a large 17th-century English *dining table;* in the west bay, near the entrance to the Hutton Hall, there is a very fine *trestle table* of **c.**1500 which originally stood in the kitchen of Durham Cathedral Priory. The **weapons** are to be found at the entrance to the two Daylit Galleries and they date from the 16th and 17th centuries. They are variously of Italian, French, German and Austrian manufacture. Two *spears* and a *halberd* were made in 1558 for the service of Ferdinand I, King of the Romans (later Holy Roman Emperor) and their blades bear his engraved device and initials.

About eighteen tapestries can usually be seen in the Tapestry Gallery, although this number will fluctuate as changes are made at regular intervals. The most instructive way to examine them is by beginning with the earliest, the **German and Swiss tapestries,**

35 *The Tapestry Gallery. Photograph by Alastair Hunter*

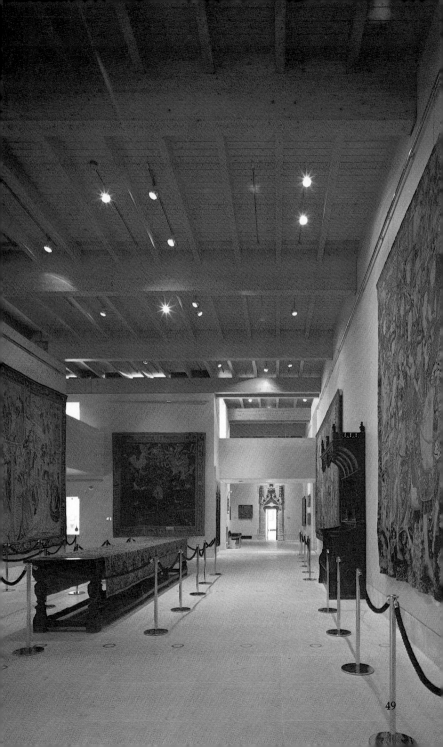

49

which hang in the east bay, next to the Gothic Domestic Room. Most are quite small and those with religious subjects were used as **36** altar frontals. *Scenes from the Life of Christ and of the Virgin* next to the Beaudesert Screen is an example of these. Below the Nativity kneels a Dominican nun, almost certainly the donor of the tapestry, which was probably woven in Basle.

German tapestry weaving never became a highly organized commercial industry, and seems to have been carried out in small workshops in convents and houses. The products are not very sophisticated but they are appealing largely because of the naivety and almost childlike simplicity of the designs, as in the *Bible Tapestry* on the wall opposite to the Beaudesert Screen. This was woven in the Middle Rhineland during the early 16th-century and has thirty-four Old Testament and two New Testament scenes, representing a synopsis of Bible history from the Creation (in the upper left corner) to the birth of Christ (lower right). It is thus the medieval equivalent of the modern cartoon strip.

By no means all of the German tapestries depict religious subjects. The earliest tapestry in the entire Collection, the *fragment* woven *c*. 1300 in or near Freiburg-im-Breisgau, southern Germany, which is displayed on the wall between the east bay and the

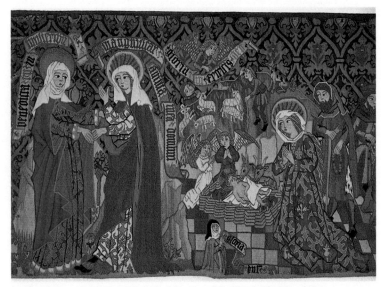

36 Tapestry: *Scenes from the Life of Christ and the Virgin (detail)* *Swiss,* *c*.1450-75 *Wool and linen, 96·5×259·1cm (38×102in) Reg. no. 46/46*

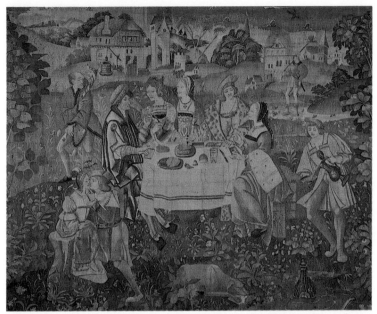

37 Tapestry: *Open-Air Meal in the Garden of Love Franco-Netherlandish, early 16th century Wool and silk, 292·7×362·0cm (9ft 7¼in×11ft 10½in) Reg. no. 46/66*

European Daylit Gallery, has interlaced lozenges filled alternately with monsters and pairs of birds. Another example is the charming scene of peasants *haymaking*. This was almost certainly part of a set of Labours of the Months and was intended to hang in a private house. The wealthy patrician families of the German cities were the main patrons of these tapestries and the owners or donors of several in the Burrell Collection are known.

The simple and direct style of some of the German tapestries is a far cry from the accomplished products of the contemporary **Netherlandish and French** weavers, examples of which can be seen in the main section and in the east bay. The well-known *Peasants Hunting Rabbits with Ferrets* in the west bay was probably woven in Tournai and it is one of the finest tapestries of the period, displaying a sense of movement and naturalism together with an interest in perspective. Scenes of rustic life and pastoral feasting and dalliance were common subjects, exemplified by the *Camp of the*

37 *Gypsies* and the *Open-Air Meal in the Garden of Love,* both of which also hang in the west bay. Representations of rulers and the members of their courts appear in some tapestries. The huntsman

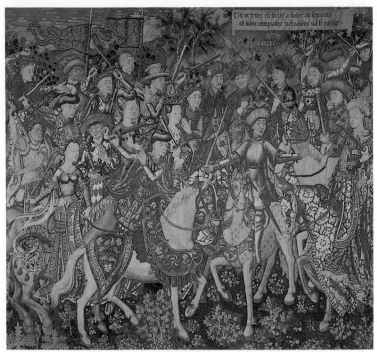

38 Tapestry: *Hercules Initiating the Olympic Games* Franco-Burgundian, *c*.1450-75 Wool, 386×477·5cm (12ft 8in×15ft 8in) *Reg. no.* 46/80

in *The Flight of the Heron* in the west bay bears a very strong resemblance to portraits of the French king Francis I (1515-1547), and two of the Burgundian dukes, Philip the Good (1396-1467) and his son Charles the Bold (1433-1477), can almost certainly be **38** recognized in *Hercules Initiating the Olympic Games*, displayed in the main section. *Hercules* was very probably a ducal commission and tapestries in France and the Netherlands were highly prized by rulers and their courts.

Several of the hangings can be associated with important personalities. The *Triumph of the Virgin*, which dominates the central section, may have been commissioned by Cardinal Wolsey to hang at Hampton Court, and the *millefleurs* (see p.27) tapestry with the shield suspended from a tree was made for Gabriel Miro (hence the punning device of the mirror on the shield), physician to the French king Louis XII (d.1515) and subsequently to his daughter Claude, queen to Francis I. The Miro tapestry is particularly

interesting as it shows a development of the *millefleurs* background into a more naturalistic landscape setting; also because the robes of the angels and the humanistic script of the motto in the border show the influence of the Italian Renaissance on tapestry weaving in northern Europe.

39 The STAINED GLASS ROOM, next to the central section of the Tapestry Gallery, contains some of the smaller and some of the most important items in this section of the Collection. They are artificially lit from behind and can therefore be viewed at all times. The display is also arranged at a height which allows close inspection. The rarest panel is the first on the left, depicting the *Prophet Jeremiah*. This is one of the earliest surviving examples of

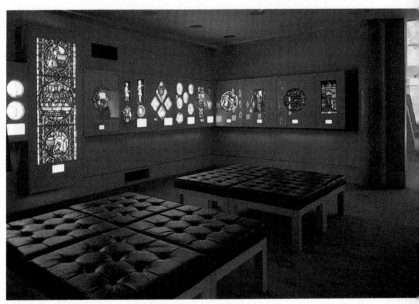

39 *The Stained Glass Room. Photograph by Keith Gibson*

European figural as opposed to ornamental glass, for it formed part of the mid 12th-century glazing of St Denis Abbey, just outside Paris. Some 13th-century panels are displayed in the right-hand section, including the figure of *Beatrix van Valkenburg*, third wife of Richard, Earl of Cornwall, son of King John and brother of Henry III. The centrepiece consists of three medallions representing *The Marriage at Cana* and the preparations for the wedding feast from a window painted in *c*.1280 for Clermont-Ferrand Cathedral in

Gallery Plan

	Ancient Civilizations
1	**Oriental Art** Carpets and Near Eastern Ceramics
	Medieval and Post Medieval European Art
2	Stained Glass and Furniture
3	Tapestries
4	Needlework and Lace
5	Sculpture
	Period Galleries
6	Elizabethan Room
7	17th and 18th Century Room
8	Gothic Domestic Room
	The Hutton Castle Rooms
9	Drawing Room
10	Hall
11	Dining Room
12	Temporary Exhibition Area
13	Lecture Theatre
14	Courtyard

France. Amongst the outstanding examples of early 14th-century south German glass with its characteristic vibrant colours are the *Virgin* and *St John the Baptist.* From the same century but of English origin is the *Somery shield of arms,* an excellent example of heraldic art. Amongst the other English medieval shields of arms is that of *Sir Henry Fitzhugh* (d.1424) enclosed within the badge and motto of the Order of the Garter. There are several examples of the Norwich School of glass-painting, including an *Archangel blowing a trumpet.* Of considerable historical importance is the half-length figure of *Princess Cecily,* one of Edward IV's daughters. Painted around 1485, it comes from the 'Royal' window in the northwest transept of Canterbury Cathedral.

During the 15th and 16th centuries it became fashionable to place **roundels** in private houses in northern Europe. A subject frequently represented on them was the Labours of the Months, and the Burrell Collection includes roundels from various sets on this theme. The Netherlandish roundels of this period are the finest, especially those depicting New Testament scenes and saints. Small roundels and panels continued to be used to enliven domestic glazing after the Reformation and particularly attractive work was produced in Switzerland and Holland. In the former country, representations of the standards and arms of individual towns were common in the late 16th and early 17th centuries. There is a good panel dated 1605 depicting a soldier holding the banner of

41

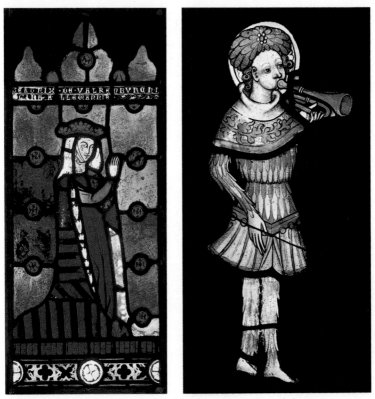

40 Beatrix van Valkenburg *English, late 13th century Stained glass, 61·0×26·7cm (24×10½in) formerly in the collection of Sir William Jerningham at Costessey Hall, Norfolk. Reg. no. 45/2*

41 Archangel Blowing a Trumpet *English, Norwich School, c.1450-1500 Stained glass, height 39·3cm (15½in) Formerly in the Philip Nelson Collection. Reg. no. 45/84*

the town of *Zug*. In Switzerland glass-painting was often practised by several generations of the same family, and a roundel dated 1671, which is part of a series of scenes from the life of *St Francis,* is the work of **Michael Müller IV** of Zug. Dutch 17th-century roundels usually consist of simple designs, often a married couple or a shield of arms. One is of particular interest in that it depicts a slate-cutter carrying out his trade. This roundel is dated 1662. On the east wall opposite the stained glass display are three Swiss designs for stained glass. That signed by **Jacob Weber** of

Winterthur is a preliminary drawing to be shown to a client for approval. The other two take the process a stage further and have the lead-lines marked in brown and the colours to be used are indicated by initials and words, e.g. *rot* for red. These drawings date from the late 16th and 17th centuries.

The LACE AND WHITEWORK ROOM lies beyond the **42** Beaudesert screen as you leave the Tapestry Gallery. A magnificent vista unfolds from the Screen through the Lace and Whitework, the Medieval Room and the round-headed arch at its entrance to the north wall and woodland beyond. Further east you will find another enclosed room, devoted to a selection from Sir William's NEEDLEWORK collection with decorative arts of the same period displayed alongside.

In both these rooms, the nature of the materials displayed and

42 *Vista through the Beaudesert Screen in the Tapestry Gallery to the North Wall. Photograph by Keith Gibson*

their sensitivity to light, oblige us to change the items on show as frequently as is practicable. There are over 300 items of needlework and 120 examples of lace in the collection. Emphasis in the needlework is on the 16th and 17th centuries, comprising one of the

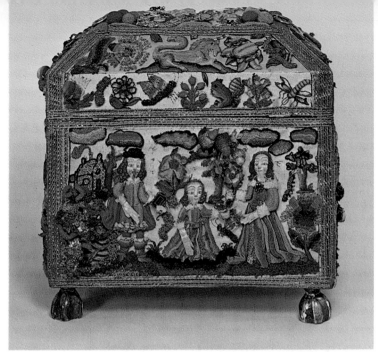

43 Cabinet With Pastoral Scenes and Animals *English, c.1650-1700 Coloured silks with metallic purls on satin, raised and padded work, 25·4×25·4×17·8cm (10×10×7in) Reg. no. 29/169*

44 Cap and Gloves *English, late 16th century (cap), mid 17th century (gloves) Cap: Coloured silks and silver-gilt thread on linen, 21×27cm (8³/₁₀×10¹/₂in) Reg. no. 29/135 Gloves: Coloured silks and silver on leather, length 30·5cm (12in) Reg. no. 29/139*

45 Sampler
English, dated 1664
Coloured silks on linen,
52·1×22·9cm (20½×9in)
Inscribed,
'Eleszebeth Fares
royght this sampler
ended in the 4 day
of April 1664'.
Reg. no. 31/23

most important collections in public ownership. Some is skilled amateur work but much of it is professionally produced and is of an exceptionally high standard. Most is English in origin, although several pieces are believed to be Scottish. Needlework pictures bring us stories from mythology, from the Old and New Testaments and from more recent history, all with a supporting cast of amusing and intriguing animals, insects, fish and birds. A panel depicting *King Ahasuerus receiving Esther* (Esther II) is particularly important because it is dated 1648 and has the arms of the Crispe family, to which it originally belonged, embroidered on the tester

43 behind the King. There are also some very attractive *cabinets* embroidered not by professionals but by young girls in well-to-do households. They contain numerous drawers, writing utensils and mirrors and they acted as a combination of vanity and writing case

and jewellery and trinket box. The embroidered exteriors frequently depict Old Testament scenes: a favourite was the story of Abraham and Isaac.

45 Young ladies began their needlework training not with cabinets and picture panels, but with *samplers*. Samplers continued to be made well into Victorian times, but the earliest, which date from

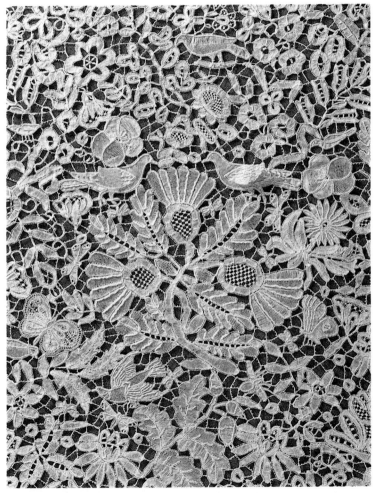

46 Flounce *(detail)* *English Honiton lace, 19th century* *Linen, 45·8×442·2cm (18in×14ft 6in)* *Reg. no. 24/96*

the late 16th and 17th centuries, were as the name suggests examples of different types of work and not the quaint pictures they later became. The Burrell Collection includes a fine group of 17th-century samplers displaying a variety of subjects and techniques. Some are signed and dated, including the linen sampler with raised and padded work embroidered by **Frances Cheyney** in 1664 and another, worked in coloured silks and metal thread on linen by **Jane Turner** in 1668. Certainly the most astonishing exhibits, for their technical achievement, are the beadwork presentation baskets, which have survived despite their extreme fragility.

The LACE collection ranges in date from the 16th to the 19th centuries and includes examples of needle and bobbin lace from all the great European centres: Italy, France and Belgium. England is represented by Honiton lace; later pieces include early examples of machine knitted lace of the 19th century. Embroidered nets, giving the appearance of lace, are exhibited alongside. Many of the pieces demonstrate the fashion of their period: lappets, flounces, shawls, caps, ruffles, frills and astounding collars which give an insight into the luxury and extravagance of the European society which produced them. We can only marvel at the technical expertise which can produce butterflies, flowers, figures and intricate patterns from miles of linen thread.

The decorative arts of several centuries may be viewed in the suite of three PERIOD ROOMS running from south to north in the building, which were created to give an impression of domestic interiors. The first of the Period Rooms is the GOTHIC DOMESTIC ROOM. The most reliable evidence we have for late medieval domestic interiors in northern Europe is provided by the paintings of Netherlandish artists such as Jan van Eyck, Rogier van der Weyden and Hans Memling; the Gothic Domestic Room contains furnishings and objects which appear in such pictures and which could have been found in the house of a well-to-do merchant or gentleman of the period *c.*1475-1525. The *oak panelling* with its frieze of Renaissance-style motifs along the end wall of the room was originally in a medieval merchant's residence in Ipswich which subsequently became a public house, the Neptune Inn. One of the two small *tapestries* in this room was also owned by a merchant: the hanging depicting *King David and Bathsheba* bears the shields of arms of Heinrich Ingold, a Strasbourg merchant in the late 15th century, and his wife Clara.

Little is known about the other large furniture items in this room

47 *The Gothic Domestic Room with the Bridgwater Ceiling. Photograph by Keith Gibson*

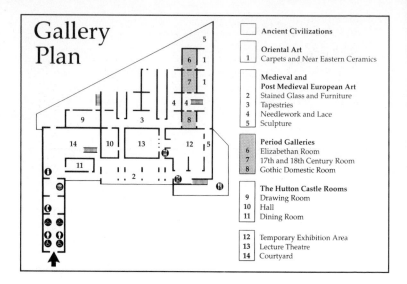

Gallery Plan

	Ancient Civilizations
	Oriental Art
1	Carpets and Near Eastern Ceramics

Medieval and Post Medieval European Art
2 Stained Glass and Furniture
3 Tapestries
4 Needlework and Lace
5 Sculpture

Period Galleries
6 Elizabethan Room
7 17th and 18th Century Room
8 Gothic Domestic Room

The Hutton Castle Rooms
9 Drawing Room
10 Hall
11 Dining Room

12 Temporary Exhibition Area
13 Lecture Theatre
14 Courtyard

but most of them must have come from domestic residences, including the Netherlandish oak *armoire* or cupboard; the Renaissance-style carved decoration with male heads dates it to the early 16th century. The openwork traceried windows on the English *oak hutch*, or small cupboard, had a practical as well as ornamental function, for they permitted ventilation of the food stored within.

The *oak ceiling* above the Gothic Domestic Room has some fine carved bosses and other decoration. During the 19th century this

48 Mazer Bowl *English, c.1500 Maplewood and silver-gilt, diameter 25·4cm (10in) Reg. no. 43/62*

49 *The Seventeenth and Eighteenth-century Room showing the English bureau cabinet and, on the end wall, the Portrait of a Gentleman by* Frans Hals. *Photograph by Keith Gibson*

excellent example of English late medieval craftsmanship was **47** installed in a coffee-house at Bridgwater, Somerset. This was not its original location, for it was cut down to fit the coffee-house and it is likely that it previously formed part of the roof of a church in the neighbourhood. The *Bridgwater Ceiling* has been placed in a domestic setting in the gallery as it resembles timber ceilings in houses like that owned by Thomas Paycocke at Great Coggeshall in Essex. Amongst the bosses is a Tudor rose surmounted by a crown and the boar device of Richard III, which point to a late 15th-century date.

The two recessed showcases contain a variety of *domestic utensils*, including large brass plates manufactured in Nuremberg, bronze candlesticks, a ewer and a bronze chafing dish used to warm food. Amongst the more luxurious items is a German late 15th-century *drinking horn* with silver-gilt mounts and a fine group of popular **48** medieval drinking vessels, known as *mazers*.

Even in private houses religion was ever-present. In northern Europe most if not all of the domestic residences of the well-to-do had small altarpieces for private devotional use. The *altarpiece* displayed in one of the cases is an example of a type known to have

been used in English late medieval houses. It consists of an alabaster panel carved with the head of St John the Baptist on a plate which is surrounded by the figures of saints whose names are painted along with other devices on the inside of the two oak wings or leaves.

49 The SEVENTEENTH AND EIGHTEENTH-CENTURY ROOM is reached from the Gothic Domestic Room via the Lace and Whitework Gallery. Hanging on the west and south walls is a selection of 17th-century Dutch pictures, of which pride of place

50 goes to the **Rembrandt** *Self-Portrait*. The precision of the church interiors by **Hendrick Cornelisz van Vliet** (1611/12-75) may be compared with Bosboom's more impressionist treatment of the same subject. Holland in the 17th century was at the height of its power and prosperity, based on the entrepreneurial skills of the city and town burghers who were the main patrons of the painters. *Jacob Trip* was a merchant of Dordrecht whose forbidding portrait painted in 1657 by **Nicolaes Maes** (1634-93) captures the stern Calvinistic nature of the Dutch burghers. Maes was a follower of Rembrandt, who also painted portraits of Trip and his wife. The *Portrait of a Gentleman* by **Frans Hals** is a freer and less austere treatment of another member of the well-to-do classes. This picture was Sir William Burrell's most expensive acquisition: it cost him £14,500 in 1948.

It is not hard to understand why Dutch 17th-century paintings appealed to Burrell's reserved, somewhat frugal nature. For the same reason the frills and fripperies of Baroque and Rococo art failed to attract him and his purchases in this field were almost entirely confined to the relatively restrained fields of British portraiture, furniture, glass and silver.

18th-century portrait painting was one of Burrell's early enthusiasms and he continued to make a few acquisitions in this field after the First World War. The most important of these was by **William Hogarth** (1696-1764), the portrait of *Mrs Ann Lloyd*. Portraits by the following artists can also usually be seen in this room: **Nathaniel Hone** (1718-84), **Sir Henry Raeburn** (1756-1823) and **George Romney** (1734-1802) (of the playwright *Richard Brinsley Sheridan*). The most eye-catching item of furniture is the *walnut bureau cabinet,* a magnificent example of the art of the English cabinetmaker. It was made in about 1705 and comes from Castle Howard in Yorkshire.

The recessed showcases at the north end of the room contain a selection of early 18th-century **English decorative art.** The glass includes tapersticks, and wine and cordial glasses. Most of the

50 Rembrandt van Rijn: *Self Portrait, signed and dated 1632. Oil on panel,*
63·0×47·0cm (24¾×18½in) This painting was formerly in the French royal collection
before its dispersal in 1792. Reg. no. 35/600

silverware exhibited was made by London goldsmiths, although
there is a *stem bowl* made in Edinburgh by **James Mitchellsone** in
1726-27. A silver-gilt *caster* hallmarked London 1710-11 also has
Scottish connections in that it is engraved with the arms of the
Marquess of Lothian.

Beyond the Seventeenth and Eighteenth-Century Room lies the ELIZABETHAN ROOM, containing items primarily from the reign of Queen Elizabeth I (1559-1603), along with some dating from the time of her successor James VI of Scotland and I of England: there was a strong artistic continuity during the period spanned by the two reigns. A number of the artefacts can be associated in one way or another with Queen Elizabeth herself. The large *oak fireplace* and overmantel occupying the end wall date from the late 16th century and reputedly come from the destroyed Tudor royal palace of Oatlands, near Weybridge in Surrey. This is not entirely certain, but the display of the arms of England suggests a royal connection of some kind. The elaborate carvings of caryatids, lion masks, mermaids are all part of the standard repertoire of ornament used in Elizabethan and Jacobean England. *The Kimberley Throne* is another item in this room which can be linked with Queen Elizabeth. It was discovered at Kimberley Hall in Norfolk, the residence of the Wodehouse family. Traditionally it has been associated with a visit made by the Queen to Kimberley in 1578.

51

Other items are connected with members of her Court. On the wall opposite the fireplace hangs a portrait of the great statesman *William Cecil, Lord Burghley* (1520-98), resplendent in his robes and insignia of the Order of the Garter. There are several versions of this picture, all attributed to the school of **Marcus Gheeraerts**; they were probably painted around 1585. The *tapestry* on the west wall depicts the arms and supporters of the Queen's ill-fated favourite Robert Dudley, Earl of Leicester (1532-88), and is one of a set woven in 1584-5 for the banqueting house attached to his residence in the Strand, London. The tapestries were obtained from Richard Hicks, head weaver of the Sheldon tapestry manufactory, and they are almost certainly of English origin. The late 16th-century *Jack Clock*, so named from the seated figure which strikes the quarters and hours, is one of the small group of time-pieces in the Collection; painted on the dial-plate are the arms and crest of the Avery family. The *oak table* is worth a close inspection. The elaborate inlays in lighter-coloured wood include the initials IB and MB, the arms of the Brome and Crossley families and the date 1569, all enclosed in strapwork cartouches and other Renaissance designs. There is a very similar table at Hardwick Hall in Derbyshire.

Strapwork also appears in profusion on some of the **silver** displayed in the showcases in this room, including the *communion cups*. The most elaborate pieces are the three silver-gilt *steeple cups*, so-called because of the tall pinnacles on the lids; they were made in London in 1611-12. The London goldsmiths did not have a

51 The Kimberley Throne *English and Italian or French, 16th century Gold and silver thread, coloured silks and applied satin on red velvet; padded work, height 336cm (11ft) Reg. no. 14/217 Photograph by Keith Gibson*

monopoly of production in the Elizabethan and Jacobean periods. Exeter was an important centre and works by **John Jons** and **C. Eston** from that city are shown here. The latter was responsible for the mounts on a *stoneware jug* dated 1589. Not all tableware of these epochs was of silver; until the 18th century most simple household vessels were made of wood. These are known as **treen**, and there are some very good examples in the Burrell Collection. The *Hickman Chalice* and several of the other cups reveal their indebtedness to goldsmiths' designs. The sycamore *trenchers* or platters carry verses which were sung or read out by the guests whilst dining.

PAINTINGS were among the first works of art that Sir William Burrell acquired. He was already buying pictures in his teens and he was still amassing them two years before his death. His first taste was for 18th-century British portraiture, but before 1900 he

52 Communion Cups *English, (1) hall-marked London 1576-7 (2) dated 1574 and with the maker's mark of John Jons of Exeter Silver, height (1) 17·2cm (6⁵/₈in) (2) 17·5cm (6¹/₈in) Reg. nos. 43/9, 10*

had turned his attention to the Hague and Barbizon Schools and the contemporary 'Glasgow Boys'. Burrell's preferences in paintings were very strongly influenced by the art dealer Alexander Reid, who opened a gallery in Glasgow in 1889. Up to the 1920s Burrell bought consistently from him and it was Reid who pointed him in the direction of artists such as Boudin, Degas and Manet.

Sir William's paintings can be viewed in the four Mezzanine rooms, reached by a staircase from the Ancient Civilizations display in the South Gallery, or from the Embroidery Gallery. The first room contains the **Old Masters**, rooms two and three show the strength of the Collection in the French 19th century schools, whereas the fourth room is for changing displays drawn from this marvellous, and personal, collection.

54 Amongst the Old Masters, in the first Mezzanine Room, we can view *The Stag Hunt* by **Lucas Cranach the Elder** (1472-1553), which depicts an actual event. In the foreground is the Holy Roman Emperor, Maximilian I (*d.*1529). Other notable paintings are *Cupid* **53** *the Honey Thief complaining to Venus*, dated 1545, also by Cranach, and two works by **Hans Memling** (*c.*1433-94), *The Flight into Egypt* and an *Annunciation*, one panel from a triptych.

Sir William Burrell was a northerner by temperament and upbringing and he did not care overmuch for Italian art. It is somewhat ironic, therefore, that amongst the treasures of the Collection should be the **Florentine School** *Judgement of Paris*, and

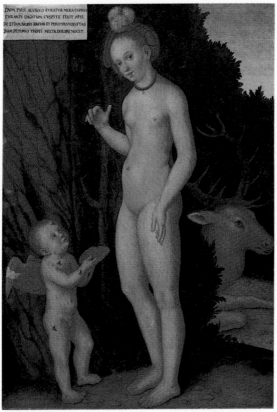

53 Lucas Cranach the Elder: *Cupid the Honey Thief Complaining to Venus, signed with the winged serpent device and dated 1545 Oil on panel, 51·5×36·2cm (20¼×14¼in) Formerly in the collection of Sir Thomas Gibson Carmichael, Bart. Reg. no. 35/74*

the *Virgin and Child* by the Venetian artist **Giovanni Bellini** (active *c*.1459-1516). The latter may be accompanied by another fine work of contemporary Italian Renaissance sculpture, a marble bust of a boy which is possibly the work of the Florentine sculptor **Benedetto da Maiano** (1422-97).

Sir William's deep love of French 19th century painting is revealed in the second Mezzanine room — and the variety of images is striking.

Honoré Daumier (1808-79) is best known for his political and social caricatures which appeared in various journals, but canvases such as *The Heavy Burden*, reveal that he had a similar outlook on life

54 *The first Mezzanine Room, displaying the Old Master paintings.*

as **Gustave Courbet's** (1819-77) *Charity of a Beggar at Ornans.* Burrell liked Daumier's work and there are no fewer than nine oil paintings and nine watercolours and drawings of his in the Collection. It is possible that Burrell may have seen something of himself in *The Print Collector,* Daumier's study of a gentleman-connoisseur inspecting prospective purchases.

Other works sometimes hanging in this room are by the **Barbizon School**, a group of landscape artists who frequented Barbizon, near Paris. The images of peasants by **Jean François Millet** (1814-75) express the nobility as well as the drudgery of agricultural labour, whereas **Jean-Baptiste Corot** (1796-1875) and **Charles François Daubigny** (1817-79) painted the countryside as they saw it and not as the idealized pastoral idyll favoured by previous generations of painters.

Eugène Boudin (1824-98) spent most of his life painting along the coast of his native Normandy. In his choice of subjects, in particular of outdoor subjects, he was a major influence on several of the Impressionist artists. Trouville, at the mouth of the Seine, was a fashionable resort at the time, but in his paintings of it, *The Jetty at Trouville* and *The Empress Eugénie on the Beach at Trouville,* he

concentrates on the atmospheric effects of sea and sky, rather than on the fashionable company. Sir William Burrell appreciated Boudin very much and there are eleven works by him in the Collection.

Burrell does not appear to have liked full-blown Impressionism and there are only comparatively minor works by **Renoir** and **Pissarro** in the Collection and none at all by Monet. The only painting he owned which comes into this category at all is *The Bell-Tower, Noisy-le-Roi; Autumn* by **Alfred Sisley** (1839-99). Given Burrell's conservative tastes, it is all the more surprising to see as avant-garde a work of Post-Impressionism as **Cézanne's** *Le Château de Médan* in the Collection. This is one of a number of Burrell's paintings which have an interesting history. It depicts land belonging to the novelist Emile Zola and the picture was owned for a time by **Gauguin**, who described it in glowing terms in one of his letters.

Gauguin was another artist who had limited appeal for Burrell. The sole example of his work in the Collection is the chalk drawing *The Breton Girl*. Similarly, Millet is represented by one work, *Winter, The Plain of Chailly*, a harsh and bleak landscape evocative of some of the novels of Emile Zola.

In the third Mezzanine room, we see work by **Edouard Manet** (1832-83) who, although generally regarded as the leader of the Impressionists, was not in sympathy with all their aims. One of the forums for discussion by artists and writers of this period was the

55 Honoré Daumier: *The Print Collector, c.1860-63 Oil on canvas, 35·5×25·4cm (14×10in) Reg. no. 35/210*

56 Eugène Boudin: *The Jetty at Trouville, signed and dated 1869 Oil on canvas 64·8×92·7cm (25½×36½in) Reg. no. 35/43*

57 Edgar Degas: *Woman Looking Through Field Glasses, c.1865 Oil on paper on canvas, 30·4×19·0cm (12in×7½in) Reg. no. 35/239*

Parisian café, which also provided the painters with plentiful subject-matter. Manet's vision of it is seen in the *Café, Place du Théâtre Français* and *Women Drinking Beer.* Manet also painted some delightful still-lifes. The broad and free application of brush strokes in his *Roses in a Champagne Glass* is in contrast to the dry and precise treatment of the same subject in *Spring Flowers* by **Henri Fantin-Latour** (1836-1904). Fantin-Latour, although a contemporary of the Impressionists, held much more traditional views on art.

The third room is dominated, however, by **Edgar Degas** (1834-1917), with at least six of his major paintings and pastels, less than a third of the total of 22 of his works in the Collection. Burrell liked Degas' pictures very much and in one letter expressed his regret that he had never met the artist. These pictures show the extent to which the worlds of ballet and horse racing provided Degas' source material; half of his 2000 surviving works are devoted to ballet subjects. Degas was not especially interested in dancing and racing for their own sake; rather he was fascinated by the shapes and movements created by such activities. Even the *Woman Looking*

57 *Through Field Glasses* (1865) is a racing subject, for the picture is a study for a figure in a racecourse scene. Of the ballet pictures *The Rehearsal* (1874) is in oils; the others are in pastel. The largest picture by Degas in this room is neither a ballet nor horse racing subject but **74** a portrait of the novelist and critic *Edmond Duranty* (1879). The artist was much influenced by Duranty's views on realism, which is reflected by the depiction of the man of letters in his study, surrounded by the tools of his trade.

The fourth Mezzanine room will be devoted to changing displays from Sir William's fine art collections, and will be used to display the works of artists who are not represented elsewhere, or to highlight themes drawn from the Collection.

Artists will include members of the Hague School, established at The Hague by 1870, who were popular with Scottish, particularly Glasgow, collectors. In common with the Barbizon School and Impressionist painters, whom they admired, the Hague School artists like **Anton Mauve** (1838-88) and the three Maris brothers, were concerned with portraying the effects of light; they were, however, more conservative than their French counterparts and it is this caution that appealed to bourgeois collectors like Burrell. During his early years as a collector he favoured the Hague School as much if not more than any other group of painters. He had a particular affection for **Matthijs Maris** (1839-1917) who had settled in London and was influenced by the Pre-Raphaelites. Burrell acquired over fifty of his paintings, drawings and prints. The choice **58** of the ethereal, almost whimsical *Butterflies* and *The Sisters* reveals

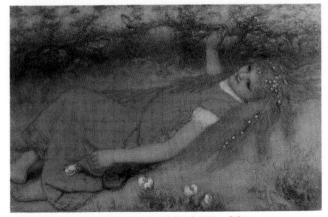

58 Matthijs Maris: *Butterflies, signed and dated 1874* *Oil on canvas, 64·8×99·1cm (25½×39in) Reg. no. 35/330*

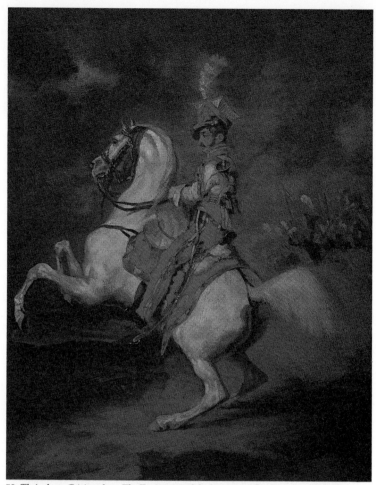

59 Théodore Géricault: *The Trumpeter of the Lancers of the Guard, c.1812-15*
Oil on canvas, 40·6×33·0cm (16×13in) Reg. no. 35/270

an unexpectedly sentimental side to Burrell's nature. *Butterflies*
inspired him in his old age to wax lyrical on artistic matters: 'He
[Matthijs Maris] was a dreamer and his pictures are poems in paint,
full of feeling and tenderness . . .'

Although **Jacob Maris** (1837-99), like his brother, had studied and
worked in Paris, he was imbued with the spirit of his illustrious
17th-century fellow-countrymen. His town and harbour scenes,

such as *Amsterdam*, painted about 1885, reveal his debt to the Ruysdael family, but his palette and interest in the effects of sky show his affinity with the Barbizon School and the Impressionists.

Other artists represented in the Collection who could find their way into the fourth Mezzanine room include Géricault, Delacroix, Jean Baptiste Oudry, Gustave Courbet, Johan Barthold Jongkind, Albrecht Dürer, Lucas Cranach the Elder, Rembrandt, Antoine Le Nain, Jean Baptiste Chardin, Johannes Bosboom, Whistler and Joseph Crawhall.

Joseph Crawhall (1861-1913) was one of the few contemporary artists patronized by Sir William Burrell, and there are more works (132) by him in the Collection than by any other artist. Burrell knew Crawhall well when the artist was a member of the 'Glasgow Boys' group at the end of the 19th century and he admired his technical mastery. If his ladies in governess carts or riding bicycles, accompanied by frenzied dachshunds, remind us of a lost Edwardian world, his portrayals of animals and birds often reveal a droll sense of humour and acute observation of nature.

Returning to the ground floor, we can continue our appreciation

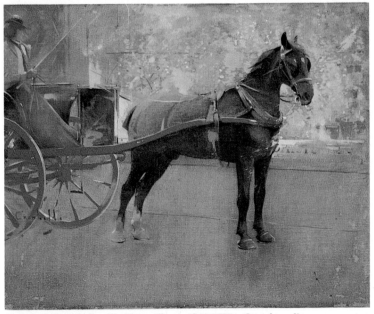

60 Joseph Crawhall: *The Flower Shop, c.1890-1905 Gouache on linen,*
27·4×34·3cm (10¾×13½in) Reg. no. 35/117

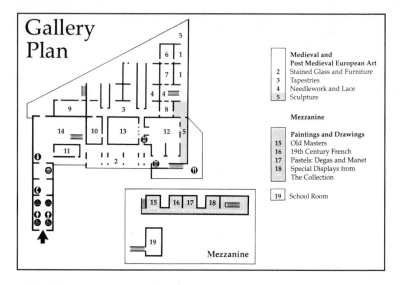

Gallery Plan

Medieval and
Post Medieval European Art
2 Stained Glass and Furniture
3 Tapestries
4 Needlework and Lace
5 Sculpture

Mezzanine

Paintings and Drawings
15 Old Masters
16 19th Century French
17 Pastels: Degas and Manet
18 Special Displays from
The Collection

19 School Room

Mezzanine

61 of Sir William's fine art collection in the BRONZES GALLERY, lying
in the south-east corner of the building through the limestone
portal from Montron near Château-Thierry in eastern France. It
dates from the late 12th century and the carved decoration
demonstrates the rich imagination of the Romanesque sculptor.

Most of the bronzes in this section of the gallery are by **Auguste
Rodin** (1840-1917), and like *The Age of Bronze* and *Eve* in the
Courtyard (see p.21), they reveal his interest in the human body.
The craggy head of *Honoré de Balzac* conveys the novelist's powerful
personality; this cast is one of several studies made for the full-
length monument to Balzac commissioned in 1891 for the Palais-
Royal in Paris but never erected there; it is now in the Museum of
Modern Art, New York. Several of Rodin's bronzes in the Burrell
Collection are casts of well-known compositions, including *Jean
d'Aire*, which is a preparatory study for one of the six figures in *The
Burghers of Calais* group. *The Thinker* is one of a number of casts for
the *Gates of Hell*, a commission which Rodin received from the
French government in 1880 for an entrance portal to the School of
Decorative Arts in Paris and which remained unfinished. *The
Thinker* represents the Italian poet Dante, pondering the fate of
mankind; it was intended to be seen from below, so the sculptor
lengthened the arms and enlarged the shoulders to give a towering
and dominating effect.

62 *The Blacksmith* and *The Gleaner* by **Constantin Meunier** (1831-1905)

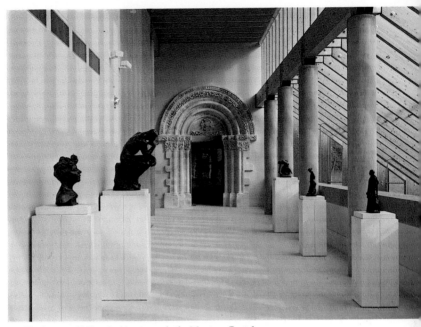

61 *The Bronzes Gallery looking towards the Montron Portal*

and **Charles van der Stappen** (1843-1910) respectively, both Belgian artists, reveal the same spirit of realism and belief in the nobility of labour as the paintings of their French contemporaries like Millet. The half-length study of *Lillian Shelley* by **Jacob Epstein** (1880-1959) is dated 1920, which makes it one of the most modern works purchased by Sir William Burrell.

There is a good view from the Bronzes Gallery down into the RESTAURANT, around which are displayed no fewer than 63 panels of 16th-century **heraldic glass**. A closer inspection can be made from the Restaurant itself, where there are two boards giving information on the glass. The panels come from three English domestic residences: *Vale Royal* in Cheshire, *Compton Verney*, Warwickshire and *Fawsley Hall* in Northamptonshire. The last series was set up in the windows of the Great Hall at Fawsley, in which formal banquets were held, so the Burrell Restaurant provides a modern setting for the glass in keeping with the original location. There are 39 panels from Fawsley, most of which commemorate the ancestry of Sir Edmund Knightley (d.1542), who built the Hall, and that of his wife Ursula, sister of John de Vere, 14th Earl of Oxford.

63

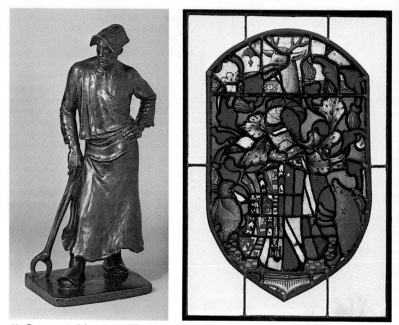

62 Constantin Meunier: *The Blacksmith* *Belgian, c.1870-80* *Bronze, height 48·2cm (19in)* *Reg. no. 7/5*

63 Arms of Sir Edmund Knightley *English, c.1530-40* *Stained glass, 78·1×47·0cm (30¾×18½in)* *Reg. no. 45/332*

The Vale Royal series includes shields of the royal arms of England and of various powerful Tudor magnates and members of the Cheshire landed gentry. The last four panels in the south-west corner of the Restaurant come from the private chapel at Compton Verney and depict the arms of leading Midlands families in enamel painted glass.

64 **STAINED GLASS** is intimately associated with architecture and for this reason the wooden supports for the external glass walls of the gallery have been used as the setting for the ancient glass, not only in the Restaurant but along the entire length of the front façade of the building. As it faces south the glass is seen to best advantage and it is interesting to watch how the colours alter during the course of the day and as the seasons change. They are at their most brilliant on frosty days or with snow on the ground; during the hours of darkness the glass is artificially lit from inside so that it can be enjoyed from the park itself. In other words, the medieval

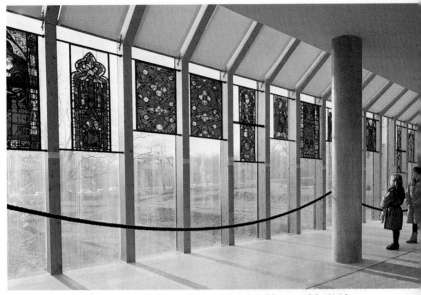

64 *The display of medieval stained glass in the South Gallery. Photograph by Keith Gibson*

glazing is seen today much as it would have appeared in its original ecclesiastical setting.

The panels, which date from the mid 13th to the early 16th century, are arranged chronologically from the corner nearest the Restaurant to the arch leading to the Hutton Dining Room and the Entrance Arm. The majority are of German origin, but they also include panels from Austria, England, France and the Netherlands. This arrangement demonstrates how glass-painting differed from region to region and how styles and colours changed over the centuries from Early and High Gothic through to the infiltration of the Renaissance into northern Europe. Several of the panels have a known provenance or can at least be ascribed to a particular area. For example, the figure of *St Jerome* comes from western France, possibly Evron. The pair of fine ornamental panels on red and blue grounds were originally in the former Augustinian church at Erfurt, in Thuringia in Germany, and the angel over the architectural canopy formed part of the glazing of the parish church at Wiener Neustadt in Austria. All these date from the first half of the 14th century. Most of the subjects represented are religious, but the twelve north German panels include scenes of daily life, such as **65** ploughing. There are several good English 15th-century panels,

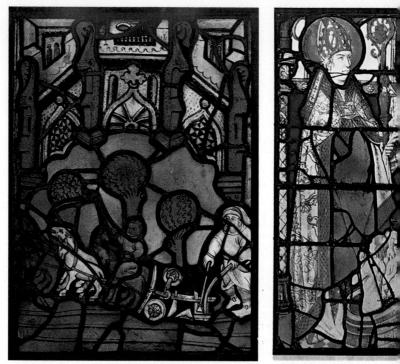

65 Ploughing *North German, early 15th century Stained glass, 68·5×49·5cm
(27×19½in) Formerly in the Collection of William Randolph Hearst. Reg. No. 45/486*

66 St Nicholas *German, Rhineland, early 16th century Stained glass,
114·3×45·1cm (45×17¾in) Reg. no. 45/439*

especially the *Annunciation* and *Assumption of the Virgin* from
Hampton Court in Herefordshire. Several come from churches in
Norfolk and Suffolk, a region which had a distinctive style of glass-
painting towards the end of the Middle Ages. The *St Mary
Magdalene* is a typical example of the work of the Norwich glaziers.
St Mary Magdalene also appears anointing Christ's feet in a late 15th-
century panel from Cologne. Several contemporary Cologne panels
depicting *Solomon and the Queen of Sheba*, the *Judgement of Solomon*
and the *Miracle at Cana,* which are set in the adjoining bays, testify
to the variety in styles that could occur amongst glass-painters even
in the same city.

Almost all the ecclesiastical as opposed to domestic glass in the
Burrell Collection was removed from churches and monasteries

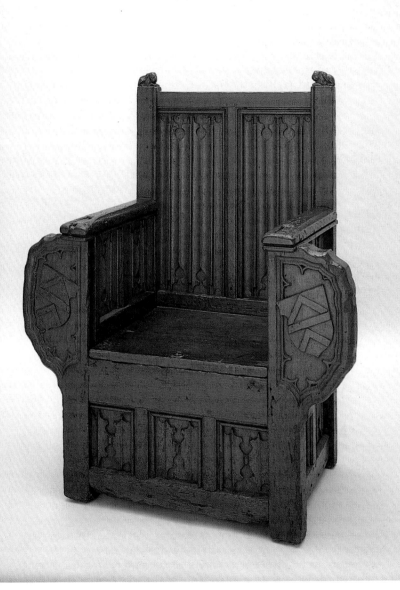

67 'Imprisoning' Armchair *English, 16th century* *Oak, height 114cm*
(45¾in) *Reg. no. 14/83*

during the secularization of religious buildings and property which swept through France, the Low Countries, Germany, Austria and Switzerland in the aftermath of the French Revolution in the late 18th and early 19th centuries. This dispersal coincided with a revival of interest in the Middle Ages amongst the English upper classes and an enormous traffic in glass took place between the Continent and the British Isles, as a result of which windows in many country houses were embellished with medieval panels. The **66** *St Nicholas* panel was imported from the Netherlands and offered for sale in London and Norwich in 1804. It represents one of the miracles performed by St Nicholas, in which the three boys in the tub are restored to life.

Opposite the stained glass, which is displayed to great effect against the daylight of the South Gallery, is a changing selection from Sir William's furniture. **WOODWORK AND FURNITURE** are dispersed throughout the building, such as in the Period Rooms, Tapestry Gallery and the three rooms from Hutton Castle. Indeed, many of the pieces were purchased for use in his home, acquired by Burrell in 1916. Although many woods can be identified, Burrell was especially fond of oak. Over 500 items in the furniture collection are of oak. "Take it from me," he said on one occasion, "You start with oak and then go to mahogany and other woods. But mark my-words you always come back to oak." Emphasis in the furniture collection is on the Middle Ages and on the Elizabethan and Jacobean periods. The earliest piece in the Collection is the chest made for Richard de Bury, Bishop of Durham between 1334 and 1345, displayed usually in one of the rooms off the North Gallery.

Chests, cupboards, tables and chairs, ranging in date from 1330s to 1700 enable us to follow the evolution of different types of furniture. The *Durham Table,* of about 1500, is a development of the medieval trestle table, whereas the *Brome Table,* dated 69 years later, is a framed table where the top is supported by a secure and permanent underframe with legs and stretchers. What we would now call cupboards—at one time literally a board or boards on which to display your cups or precious plate—or sideboards, are represented by such diverse and practical forms as the 16th century hutch or food cupboard and by the press cupboard of the late 16th century. Chairs, beam sections, stools, desk boxes, mortars, architectural details, salts, drinking vessels and even a delightful rocking cradle—the range from which to select items for display is both intriguing and extensive.

As we walk between the furniture and the stained glass, we

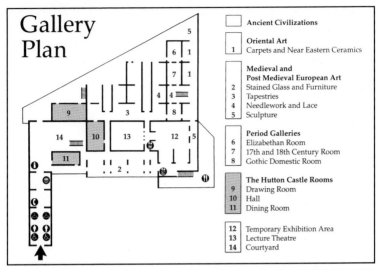

Gallery Plan

	Ancient Civilizations
1	**Oriental Art** Carpets and Near Eastern Ceramics
2 3 4 5	**Medieval and Post Medieval European Art** Stained Glass and Furniture Tapestries Needlework and Lace Sculpture
6 7 8	**Period Galleries** Elizabethan Room 17th and 18th Century Room Gothic Domestic Room
9 10 11	**The Hutton Castle Rooms** Drawing Room Hall Dining Room
12 13 14	Temporary Exhibition Area Lecture Theatre Courtyard

69 arrive at the second of the rooms from Hutton Castle: the HUTTON CASTLE HALL. This can be viewed from either of two doorways, one in the west bay of the Tapestry Gallery, and one in the passageway linking this Gallery with the south side of the building. The room is dominated by the *oak refectory table* in the centre, which is more than six metres in length and bears the date 1581. The **needlework and tapestry coverings** of the armchairs and the settee grouped around the fireplace are fine examples of English work of

67 the period *c.* 1650-1715 and may be contrasted with the *oak chair* in 16th-century style (probably made for Horace Walpole in the 18th century) which entraps the unwary sitter by means of two iron pinions concealed in the wings. This chair is placed in the corner between the Courtyard and the Tapestry Gallery walls.

The most charming of the tapestries in the Hall is the small *Flight into Egypt*, next to the fireplace. This is from a long hanging woven in the early 15th-century for the Dominican nunnery of Gnadental in Basle, Switzerland. Next to it hangs the tapestry depicting *A*

68 *Nobleman and his Lady*. Also displayed here is the third of the set of the Beaufort-Comminges *armorial tapestries* described in the section on the Drawing Room (see p.27). The **rugs and carpets** are Persian, dating from the 17th to 19th centuries, and the suits of armour are 19th-century reproductions.

68 Tapestry: Beaufort-Turenne-Comminges armorials *French, late 14th century Wool, 220×215·9cm (7ft 3in×2ft 1in) Reg. no. 46/50*

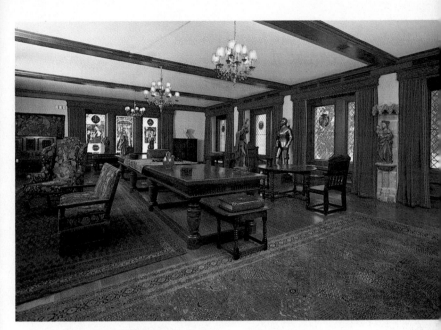

69 *The Hutton Castle Hall looking south.*

The windows into the Courtyard contain an impressive set of **heraldic roundels** dating from the latter part of the reign of Henry VIII (1509-47) and comprising royal badges and shields of arms. Four of these roundels come from Cowick Priory in Devon. Three shields have the arms of Edward VI as Prince of Wales, and one those of his parents Henry VIII and Jane Seymour. There is also some heraldic glass in the south window, but the most important contents of this window are the three large German panels depicting, from left to right, *Christ appearing to St Mary Magdalene,* the *Meeting of Joachim and Anne* (the parents of the Virgin) *at the Golden Gate,* and the *Adoration of the Magi.* They date from the late 15th and 16th centuries.

The principal architectural feature of the room is the stone *fireplace* and chimneypiece, a composite of various elements which was installed at Hutton Castle in 1937. The original jambs of the fireplace have been replaced by modern stonework. At the top right of the *oak doorway* into the Tapestry Gallery is an amusing *vignette* of a fox, dressed as a bishop, preaching to geese from a pulpit, a favourite late medieval theme. Built into the west wall is a 14th-century stone canopy and pedestal containing a French painted

85

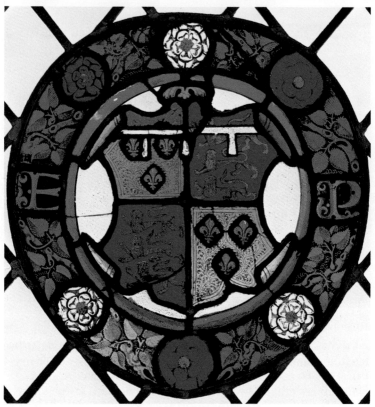

70 Roundel with the Arms of Edward VI as Heir-Apparent *English, 1537–47*
Stained glass, diameter 40·6cm (16in) Formerly in the Lucas and Radford Collections.
Reg. no. 45/185

limestone group of the *Virgin and Child*, dating from the middle of
the 15th century. Amongst the other items of **medieval sculpture** is
a bust of the *Virgin*, also in limestone and by a French carver. As
with the other two Hutton rooms, the curtains, window seats and
lampshades were made in the late 1920s and early 1930s to Sir
William Burrell's specifications.

On the other side of the early 13th-century pointed arch is the
71 Hutton Castle Dining Room. The DINING ROOM walls are
covered by a series of elaborately-carved *oak panels* dating from
c.1500. The shield of arms over the contemporary stone fireplace is
that of the Copledyke family of Harrington Hall in Lincolnshire,
from where the panelling originally came. Displayed on the

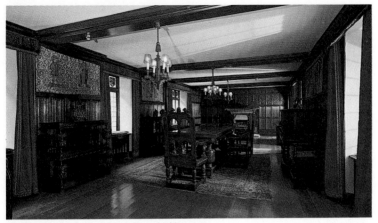

71 *The Hutton Castle Dining Room looking east.*

panelling are 15th-century **tapestry altar frontals**. That on the Courtyard side depicting St Gotthard, Bishop of Hildesheim, and St Pancras bears the arms of the Nuremberg patrician Martin Haller (d.1468) and his wife, Barbara Prunsterin. The largest represents the Coronation of the Virgin accompanied by five saints, three of whom (Erbanus, Adelarius and Bonifacius) were venerated at Erfurt in Germany, where the tapestry was probably woven. In the heads of the windows are fourteen English shields of arms. The pair in the first window on the left facing into the Courtyard are very early examples of **English heraldic glass**. They depict the royal arms and the arms of the Clare family and date from the late 13th or early 14th century.

In the centre of the room is a large Elizabethan *oak refectory table* with a parquetry top and carved bulbous legs, and a series of *oak armchairs* of the late 16th and early 17th centuries are arranged around it. More oak chairs, including a Scottish piece dated 1689, and several **oak buffet cupboards** and other 16th-century furniture are set against the panelling. Placed on this furniture is a number of *objets d'art*, including **Late Gothic sculptures and candlesticks**. The furnishings of the room are completed by a few items of Oriental and Near Eastern art, the largest being the 19th-century *Persian flower-pattern carpet*, upon which the large table stands.

Outside the Hutton Dining Room is the majestic conclusion to the stained glass display, consisting of **medieval windows.** The sequence begins with three mid 15th-century windows from the former Carmelite church at Boppard on the Rhine in Germany. The

72

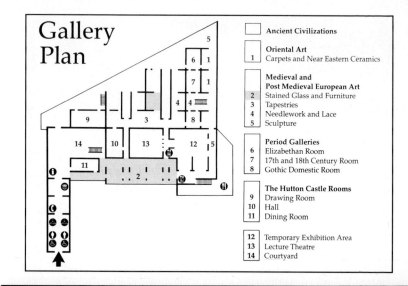

Gallery Plan

	Ancient Civilizations
1	**Oriental Art** Carpets and Near Eastern Ceramics
	Medieval and **Post Medieval European Art**
2	Stained Glass and Furniture
3	Tapestries
4	Needlework and Lace
5	Sculpture
	Period Galleries
6	Elizabethan Room
7	17th and 18th Century Room
8	Gothic Domestic Room
	The Hutton Castle Rooms
9	Drawing Room
10	Hall
11	Dining Room
12	Temporary Exhibition Area
13	Lecture Theatre
14	Courtyard

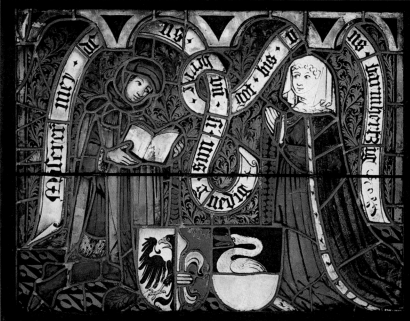

72 Boppard Donors *German, Rhineland, c.1440-50 Stained glass, 55·9×74·9cm (22×29½in) Formerly in the Pückler, Spitzer and Goelet Collections Reg. no. 45/489*

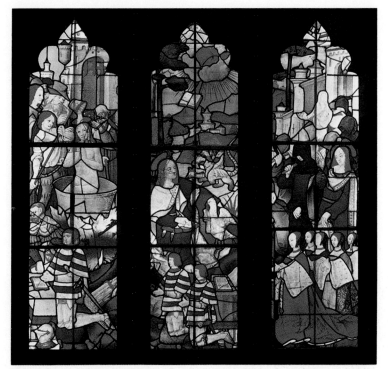

73 St John the Evangelist Scenes *French, Rouen, c.1520 Stained glass, each light 231·1×63·5cm (91×25in) Formerly in the collection of Sir William Jerningham at Costessey Hall, Norfolk.* *Reg. nos. 45/390, 391, 392*

first contains six scenes from the *Lives of the Virgin and of Christ;* below it are depictions of two donors, *Siegfried von Gelnhausen* and his wife. The second, a very tall light, depicts the *Virgin and Child and the ninth commandment* ('thou shalt not bear false witness') from a Ten Commandments window. The third of the Boppard series consists of the large figures of *St Cunibert and a bishop-saint*, set under towering canopies.

The strong colours of the Boppard group contrast with the lightness of the remaining windows, which are all French. The first pair depict episodes from the *Life of St John the Baptist* and, like the three-light window at the end of the sequence representing *St John the Evangelist Scenes*, appear to have come from the destroyed church of St John at Rouen. The Evangelist window was donated by the Bigars de la Londe family, who are depicted in the glass. The

three windows can be attributed to followers of the Netherlandish glass-painter **Arnoult of Nijmuegen** (1470-1540), who established himself in Rouen in the early 16th century. The two panels from an incomplete *Tree of Jesse* are also from Rouen and are the work of one of Arnoult's pupils. The Jesse and the St John the Baptist and Evangelist panels all date from the early 16th century. The remaining windows outside the Dining Room comprise four 15th-century scenes from the *Life of Christ*.

At the end of the stained glass sequence you return to the Shop and the Entrance Arm.

74 Edgar Degas: *Edmond Duranty*, 1879 *Tempera, watercolour and pastel on linen, 100×100cm (39¾×39½in) Reg. no. 35/232*

BIBLIOGRAPHY

Sir William Burrell

Marks, R., *Burrell: A Portrait of a Collector*, Glasgow, 1983

Marks, R., *Sir William Burrell 1861-1958*, Glasgow Museums and Art Galleries, revised edition, 1985

The Building

Architects' Journal, 'Burrell Collection Competition', (22 March 1972) pp.590-502, (29 March 1972) pp.642-4

Architects' Journal, 'The Burrell Collection', 178 no.42 (19 October 1983), pp.56-103.

Ashley, S., 'Services to Art', *Journal of the Chartered Institution of Building Services*, 5, no.12 (December 1983), pp.23-26.

Davey, P., 'Museum Piece', *Architects' Journal*, 177, no.6 (9 February 1983), pp.20-22

Gasson, B., 'Notes on the building for the Burrell Collection, Pollok Park, Glasgow', *Treasures from the Burrell Collection*, Arts Council of Great Britain, 1975, pp.117-23

Glancey, J., 'Burrell Museum, Glasgow', *Architectural Review*, 1044 (February 1984), pp.28-37

Marks, R., 'Building the Burrell', *Scottish Art Review*, XVI no.1 (May 1984), pp.3-8

The Collection

The major publications on the Collection are as follows:

Arts Council, *Treasures from the Burrell Collection*, London, 1975. This contains a comprehensive bibliography up to 1975

The Burrell Collection, with an introduction by John Julius Norwich, London and Glasgow, 1983. This has a selected bibliography of publications on the Collection between 1975 and 1983

The Burrell Collection: pictorial microfiche of more than 7000 items, published by Mindata Ltd., 1983

Scottish Art Review XVI, no.1 (May 1984). This issue is entirely devoted to the Burrell Collection

A series of leaflets on aspects of the Collection. Those so far published comprise:

 Hutton Castle Rooms *Workmen of the Pharaoh's Tombs*
 Architectural Stonework *Funerary Figures of the Tang Dynasty*
 The Assyrian Army *Degas and the Dance*
 Oak Furniture

For Young Visitors

Scott, A., *Sam goes to the Burrell Collection*, Glasgow Museums and Art Galleries, 1983

INDEX

Gallery Plan

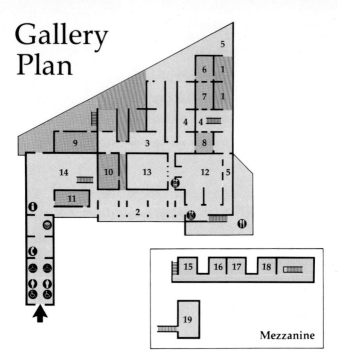

Ancient Civilizations

Oriental Art
1 Carpets and Near Eastern Ceramics

**Medieval and
Post Medieval European Art**
2 Stained Glass and Furniture
3 Tapestries
4 Needlework and Lace
5 Sculpture

Period Galleries
6 Elizabethan Room
7 17th and 18th Century Room
8 Gothic Domestic Room

The Hutton Castle Rooms
9 Drawing Room
10 Hall
11 Dining Room

12 Temporary Exhibition Area
13 Lecture Theatre
14 Courtyard

- Shop
- Enquiry Desk
- Telephone
- Cloakrooms
- Ladies Toilet
- Gents Toilet
- Disabled Toilets
- Restaurant
- Disabled Lift
- Lift
- Stairs

Mezzanine

Paintings and Drawings
15 Old Masters
16 19th Century French
17 Pastels: Degas and Manet
18 Special Displays from
The Collection

19 School Room